The College History Series

WINSTON-SALEM STATE UNIVERSITY

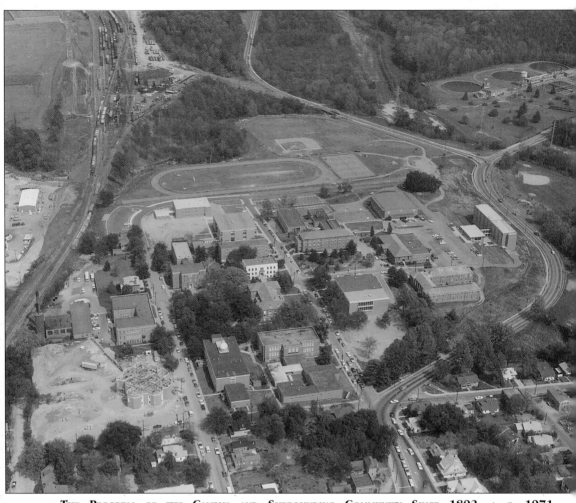

THE PROGRESS OF THE CAMPUS AND SURROUNDING COMMUNITY SINCE 1892, A C. 1971 AERIAL VIEW.

The College History Series

WINSTON-SALEM STATE UNIVERSITY

CARTER B. CUE AND LENWOOD G. DAVIS

ARCADIA
PUBLISHING

Published by Arcadia Publishing
Charleston SC, Chicago IL, Portsmouth NH, San Francisco CA

Printed in the United States of America

Library of Congress Catalog Card Number: 00-105694

For all general information contact Arcadia Publishing at:
Telephone 843-853-2070
Fax 843-853-0044
E-Mail sales@arcadiapublishing.com
For customer service and orders:
Toll-Free 1-888-313-2665

Visit us on the Internet at www.arcadiapublishing.com

This book is dedicated to the founders of Winston-Salem State University,
Dr. Simon Green and Oleona Pegram Atkins,
their immediate and distant family, friends and supporters of the university,
faculty, staff, students, and alumni.
Without these individuals, Winston-Salem State University
would not be the great university it is today.

CONTENTS

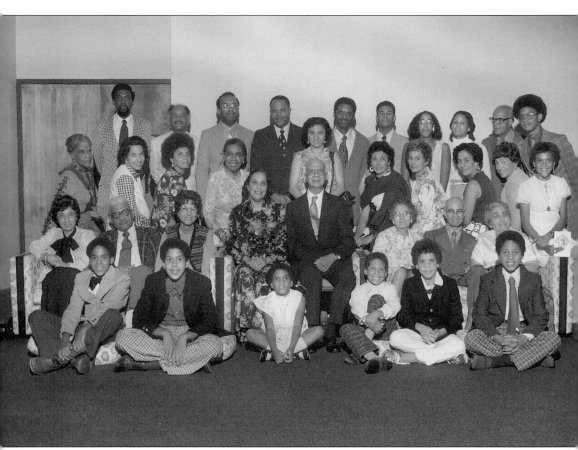

THE CHILDREN OF SIMON AND OLEONA ATKINS AND THEIR FAMILIES. Pictured from left to right are as follows: (first row) Frank Smith, Harvey Allen Jr., Stephanie Smith, Bradley Andrews, George C. Simkins Jr., and John Andrews III; (second row) Olie Atkins Carpenter*, Maurice Gleason, Eliza Atkins Gleason*, Martha Spencer Atkins, Francis Atkins*, Miriam Atkins Hamblin*, Harvey Atkins*, and Maude Smith Atkins; (third row) Anna Lee Scott, Caroline Hamblin Tucker, Elinor Atkins Smith, Frances Coble, Anna Atkins Simkins, Mary Atkins Bruce, Simona Atkins Allen, Ethel Hamblin Andrews, and Anna Smith; (fourth row) Gilbert Smith, George Simkins Sr., Harvey Allen Sr., James Tucker, Olie Barbara Hamblin, John Andrews, Kenneth Tucker, Gail Allen, Lauren Tucker, Jasper Atkins*, and Lucian Smith. (*children of Simon and Oleona Atkins.)

INTRODUCTION

The photographs and text found in *Winston-Salem State University* are the catalyst for the reader to begin a great and mighty walk through the history of a people in search of education and their place in the New World. *Winston-Salem State University* is a collective history and visual testimony celebrating the rich cultural legacy of a historically black college and university, and its unique spirit as an American institution of higher learning.

Since its humble beginnings as Slater Industrial Academy in 1892, Winston-Salem State University has played an integral role in developing our nation's future leaders and innovators in law, business, sports, politics, science, education, health care, and the arts.

To that end, this book is not necessarily meant to be the traditional pictorial history of a university, focusing solely on chronological, categorical, and historical data. Instead it is our desire to commemorate African-American life against the backdrop of college life. On the surface the photographs included herein portray the obvious experiences: graduation, military service, social and sporting activities, administrative and teaching functions, death, community service, and political life. However, on a human level, these poignant black-and-white images express real emotions: happiness, sadness, exuberance, surprise, joy, uncertainty, and anger. In short, the emotions that lend themselves to being a human being and experiencing life in the context of college life.

Winston-Salem State University also reflects on the important historical relationship between African Americans and black photographers. All too often the photographer's depiction of the people he photographed played a crucial role in how they viewed themselves in the context of American life and culture. Some of the photographs in this book were captured through the camera lens of African-American photographer Edgar T. Simons. Simons served as the official college photographer during the 1940s and 1950s.

This book is not meant to be a comprehensive view of the history of Winston-Salem State University, but a partial glimpse of the various and diverse aspects that have been a part of its long life span. Hopefully, it will endow the reader with a sense of pride and appreciation for Winston-Salem State University's determination to survive and its going quest for excellence.

—Carter B. Cue, Archivist

ACKNOWLEDGMENTS

Most endeavors are never completed by one or two individuals; there are usually numerous persons that are involved in the process—be it directly or indirectly—that help to bring any final product to fruition. This is the case with this visual history of Winston-Salem State University. Thus, it is only fitting that we acknowledge those individuals and organizations that are also responsible for this endeavor.

I would like to thank the members of the Kimberley Park and Brown Alumni Chapters of the Winston-Salem State University National Alumni Association for their financial support, which allowed the Winston-Salem State University Archives to reproduce many of the photographic negatives in its archival holdings.

Thanks also goes to the following people: Simona Atkins Allen, the late France R. Coble, Wilma Lassiter, and Louise Murphy. Their history of Winston-Salem State University helped put many of the images included in this book in their proper historical context.

I would also like to acknowledge the Bowman Gray School of Medicine's Department of Biomedical Communications for their photographic reproduction services.

I am also indebted to the staff of the C.G. O'Kelly Library, Professor Rebecca Wall, DeLois R. Cue, Professor Olasope Oyelaran, and Roger Kirkman for their suggestions, technical support, and moral encouragement. I would also like to extend a hardy thanks to John Woodard of the Wake Forest University Archives and Baptist Collection for his suggestions.

Thanks also go to the Society for the Study of Afro-American History in Winston-Salem/ Forsyth County for caring enough to preserve local African-American history. A special thanks go out to community/campus griots Ella M. Whitworth and Clarence E. "Bighouse" Gaines. These two elders added the human experience to many of the photographs included in the book.

Thanks go to Mark Berry of Arcadia Publishing for his suggestions, support, and patience with the deadlines.

Finally, thanks to African-American memorabilia collectors and educators Philip Merrill and Uhiaipou O'Malo Aiona of Nanny Jack Inc. for suggesting that I consider asking Arcadia Publishing to publish this volume.

—Carter B. Cue
Winston-Salem State University Archivist

One

BEGINNINGS

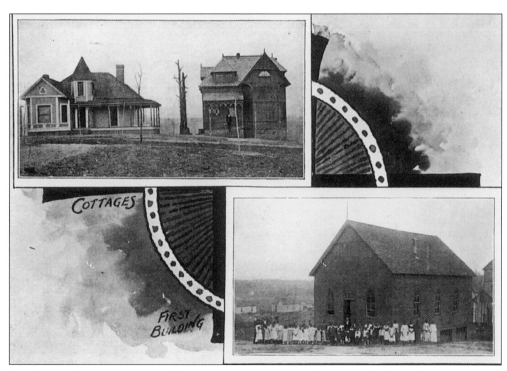

THE FIRST SCHOOLHOUSE AND TEACHERS COTTAGES, *c.* **1892**. Founded as Slater Industrial Academy in 1892, Winston-Salem State University had its beginnings in a 20-by-40-foot, one-room wood frame structure. The first student body and staff were comprised of 25 students and 1 teacher. The cottages are typical of the housing found at a later date on the Slater campus.

A Typical View of Winston-Salem, c. 1908. In the first 25 years of the 20th century, Winston-Salem was considered to be one of the more prosperous and largest cities in North Carolina.

John Fox Slater. A Connecticut textile manufacturer and philanthropist, Slater created the Slater Fund in 1882 with a gift of $1 million to help develop private black colleges and four-year high schools for African Americans. The Slater Industrial Academy, now Winston-Salem State University, was named in his honor in appreciation of his philanthropy.

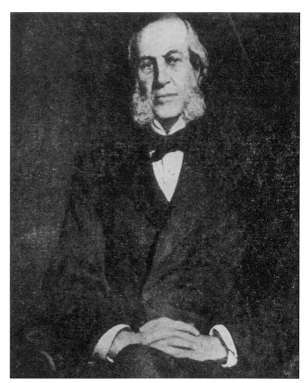

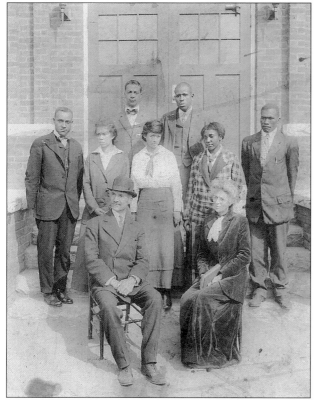

Academic Post Graduate Department Students and Dr. and Mrs. Atkins, *c.* **1916.** The purpose of the two-year post graduate curriculum was to prepare Slater students for matriculation at four-year colleges. Students were required to take courses such as Latin, geometry, and chemistry.

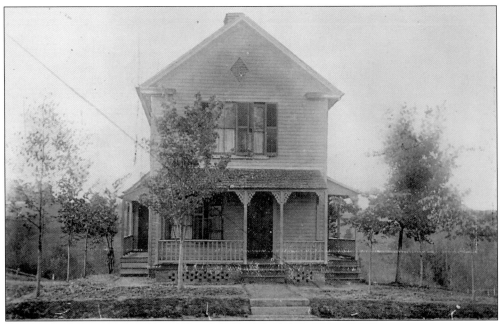

WOODY TRAINING HOME, *c.* 1910. This building was named for Quakers John and Mary Woody, two early teachers and solicitors for Slater Industrial Academy and State Normal School (Winston-Salem State University). Following the Woody's departure, the house became the principal's home. Simon G. Atkins and his family lived in the Woody house from *c.* 1914 to 1925.

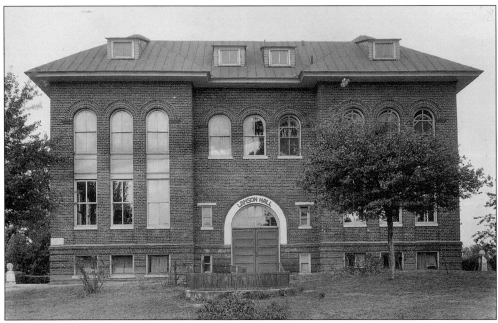

LAMSON HALL, COMPLETED BETWEEN 1897 AND 1899. This structure was named in honor of Rev. C.M. Lamson of Hartford, CT, an early contributor and supporter of Slater Industrial Academy and State Normal School. The students of Slater did much of the construction. This building was demolished in 1939 to make room for Blair Hall.

HENRY ELIAS FRIES, C. 1898. A Winston-Salem industrialist and businessman, Fries served on the college's board of trustees for 50-plus years. An innovator in his own right, he founded and built the Fries Manufacturing and Power Company. This hydroelectric dam built on the Yadkin River supplied the mills in Winston-Salem with electricity.

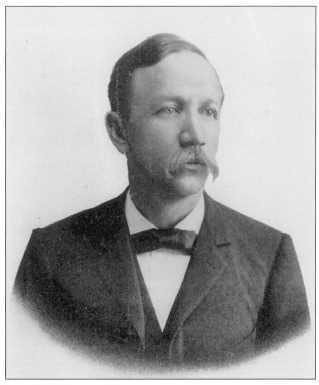

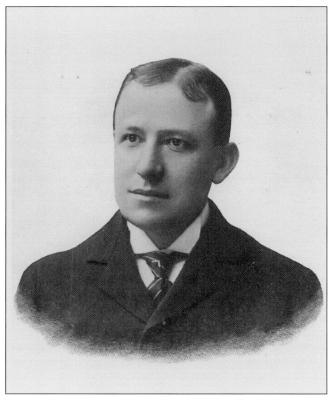

WILLIAM ALLEN BLAIR, C. 1898. A banker, lawyer, and educator, Blair was the president of Peoples National Bank in Winston-Salem. A longtime trustee and supporter of Slater Industrial Academy and State Normal School (Winston-Salem State University), he had a particular interest in human welfare and social services. In 1891, North Carolina governor Thomas Holt appointed him to the North Carolina Board of Charities and Public Welfare.

13

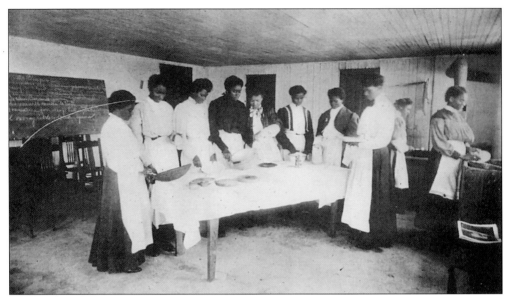

A Group of Female Students in Cooking Class, *c.* 1912. As a part of the normal school curriculum, all female students were expected to be proficient in cooking. In the Slater Industrial Academy and State Normal School, catalog cooking came under the category of science.

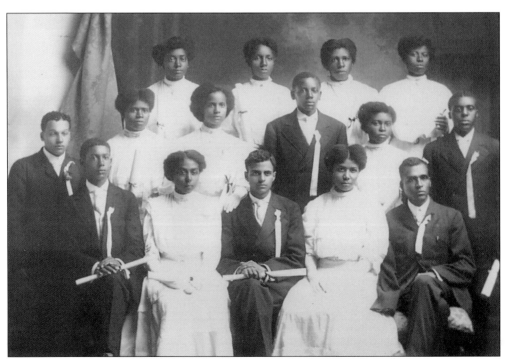

Slater Graduates, Class of 1908. The students in this photograph are posing with their diplomas. Four years later in 1912, eleven were teachers, one was deceased, two were college students, and one was a barber.

OLEONA PEGRAM ATKINS, *C.* 1915.
Educated at Scotia Women's College
and Fisk University, Oleona Pegram
married Simon Green Atkins in 1889.
In addition to teaching English, during
the formative years of the normal
school she served as an assistant and
advisor to President Atkins.

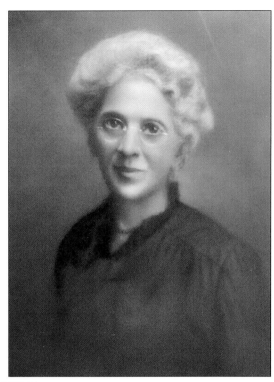

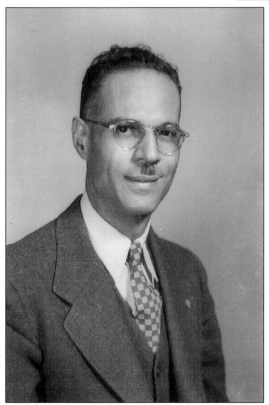

JASPER "JACK" ALSTON ATKINS, A.B., LL.B.
The son of President Simon Green
Atkins and Oleona Pegram Atkins, he
served as executive secretary to the
college president from 1936 to1961. An
honor graduate of the Yale University
Law School, he practiced in Texas
before coming back to Winston-Salem
to assist his brother, President Francis
L. Atkins. In 1959 he represented the
plaintiff in a major civil rights case,
Wolfe et al v. North Carolina.

15

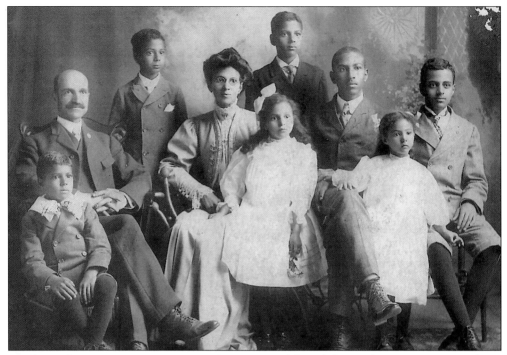

Dr. Simon Green Atkins and Family, *c.* **1907.** Pictured from left to right are Jasper, Dr. Atkins, Francis, Mrs. Atkins, Miriam, Clarence, Russell, Olie, and Harvey. The youngest daughter, Eliza, was born several years later.

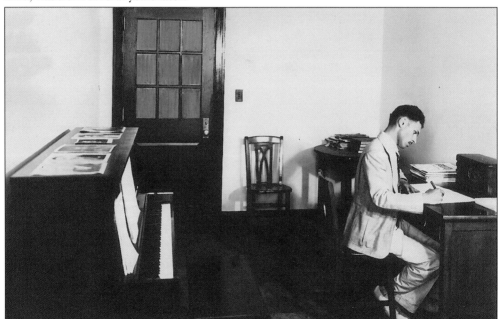

Noah F. Ryder. A music department faculty member, he composed and arranged the college's second alma mater in 1938 as a Christmas gift to the college. The first alma mater was arranged and composed in 1930 by Mary Fries Blair, wife of college trustee William A. Blair, and music department faculty member Robert C. Bolling.

SIMON GREEN ATKINS, A.B., LL.D. (1892–1904, 1913–1934). He was the founder and first president of Slater Industrial Academy (Winston-Salem State University). Atkins along with his wife, Oleona, established the town of Winston's African-American community of Columbian Heights. This community was founded on the principles of home ownership, economic self-sufficiency, and mutual understanding and cooperation between blacks and whites.

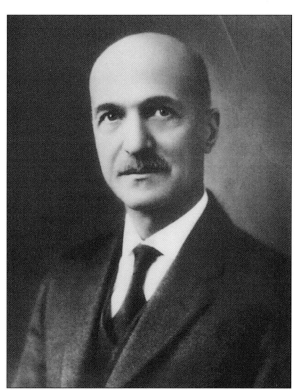

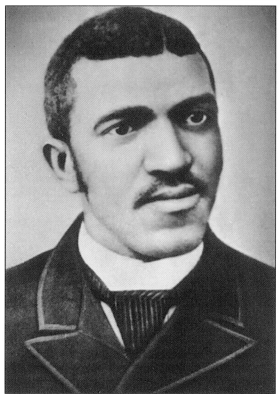

CADD GRANT O'KELLY, A.M., D.D. (1904–1910). He initially came to Slater Industrial Academy and State Normal School as an instructor of art, drama, and music. He later returned in 1898 after a short stint as principal at Kittrell College. He assumed the presidency of Slater in 1904. His tenure was brief and frustrating due to the school's meager resources and prevailing hostile racial climate.

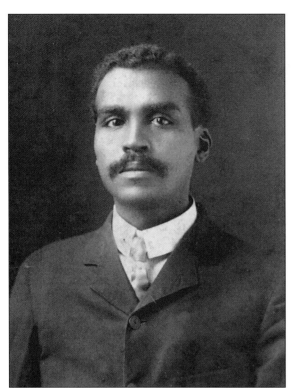

Francis Marion Kennedy, A.B., LL.B. (1910–1913). A mathematician and lawyer by training, he joined the faculty of Slater Industrial Academy and State Normal School in 1904. During his tenure as president, electricity and steam heating were installed. Also, the carpentry and agricultural programs were upgraded.

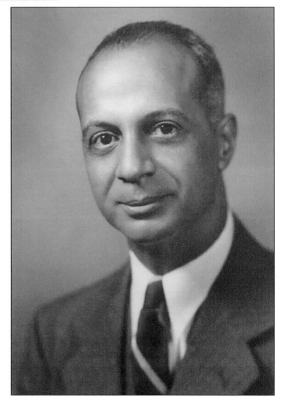

Francis Loguen Atkins, A.B., A.M., LL.D. (1934–1961). The son of the college's founders, he assumed the presidency following the death of his father. During his 27-year tenure, degree programs in teacher education and nursing were added to the curriculum, and additional academic and residence halls were constructed.

18

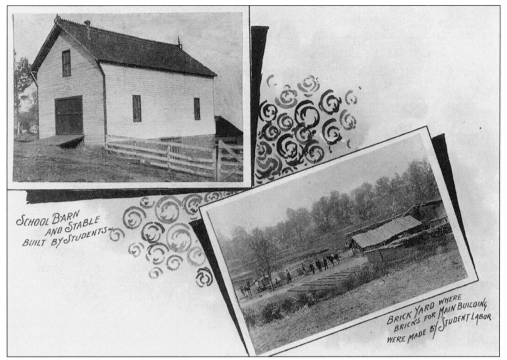

SCHOOL BARN, STABLE AND BRICKYARD, C. 1901. Since an integral part of Slater's curriculum included industrial education classes such as agricultural science, animal husbandry, and carpentry, structures such as barns were needed commodities. This picture shows a barn, stable, and brickyard constructed by student labor.

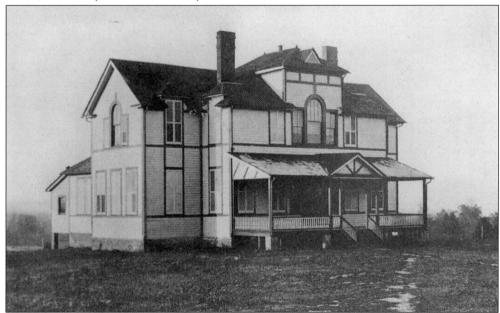

SLATER HOSPITAL, BUILT IN 1902. Located on the campus of Slater Industrial Academy and State Normal School, this wood frame structure was one of the first hospitals in Winston-Salem to provide health care to African Americans.

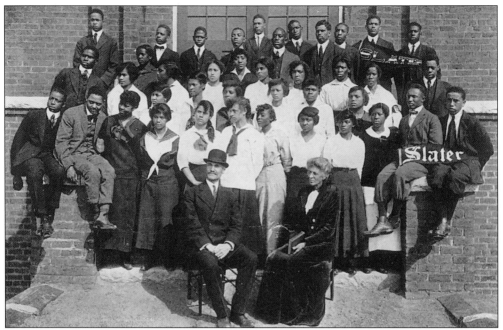

SLATER INDUSTRIAL ACADEMY AND STATE NORMAL SCHOOL STUDENTS DISPLAY SCHOOL SPIRIT, *c.* **1916.** Although students and staff generally displayed stoic, non-smiling demeanors in many of the turn-of-the-century photographs, these students seem to be in a jovial mood. Notice the pennants being held by some of the students. What school spirit!

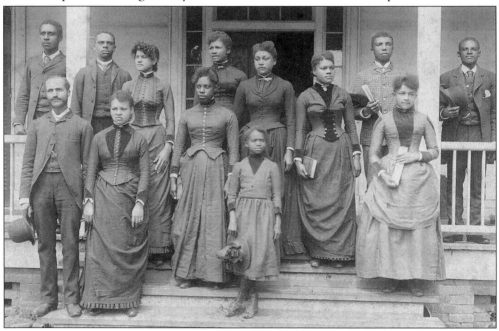

A GROUP OF SLATER STUDENTS AND PRESIDENT ATKINS, *c.* **1900.** President Atkins is in the front row to the far left. Notice the students pictured are dressed in more formal attire. These students could have been on their way to church, a school graduation, or some other special program.

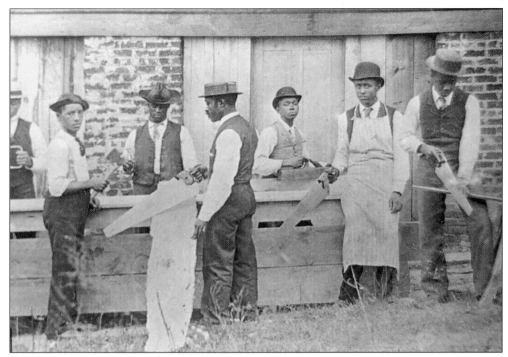

CARPENTRY CLASS, c. 1905. The early curriculum of schools like Slater included industrial arts classes such as carpentry, sewing, cooking, blacksmithing, and masonry. Many educators of the day, most notably Booker T. Washington, believed this type of instruction would make African Americans more self sufficient.

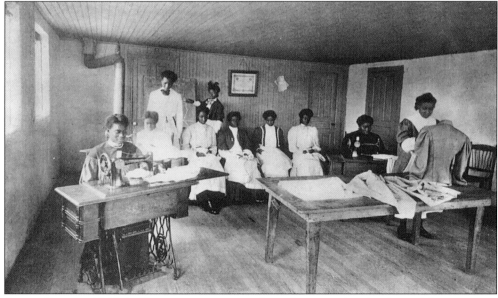

SEWING CLASS, c. 1914. At Slater sewing was taught in the normal and industrial departments. Industrial education at Slater was "not intended to supersede or overshadow" traditional literary education "but to be a coordinate branch of education—to train heart, head and hand."

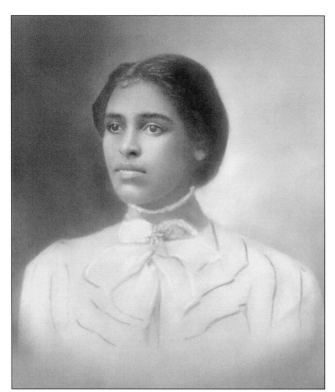

CORA BASS O'KELLY, *c.* **1906.** She graduated from the Slater Normal Department in 1900, and following graduation worked as a teacher. In 1905, a year after Cadd Grant O'Kelly was appointed president, Cora Bass and Cadd Grant O'Kelly were married.

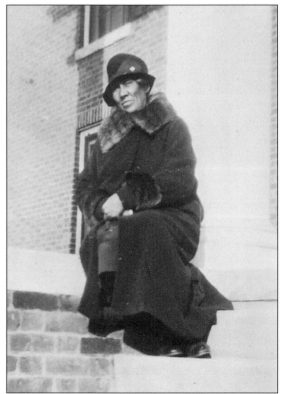

MAYME E. KENNEDY, *c.* **1920.** She was the wife of Slater Industrial Academy and State Normal School president Francis M. Kennedy. She served Slater in the capacity of home economics teacher and dormitory matron. She held the latter position from 1916 until her death in 1939.

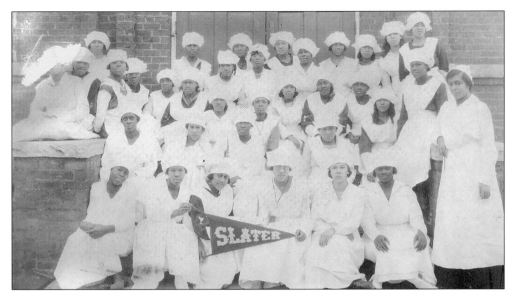

FEMALE STUDENTS IN FRONT OF HOME ECONOMICS BUILDING, *C.* 1920. These white hats and aprons suggest that these young ladies were probably students in Slater's home economics department.

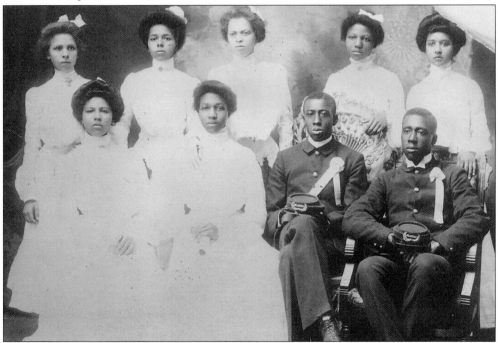

THE SLATER GRADUATING CLASS OF 1903. American colleges at the turn of the century typically had small numbers of students. This was even more so the case in the African-American community, as a result of racial and economic disparities. By 1912 the members of this class were employed in numerous occupations following graduation: Ada B. Adams (teacher), Mamie E. Diggs (teacher), Flora E. Haislip (teacher), Minnie E. Peace (domestic science teacher), Lula J. Peace (teacher), Arthur J. Wall (physician), Emily L. Gilmer (teacher), Rosa Brown (maid), and J.P. Reid (teacher).

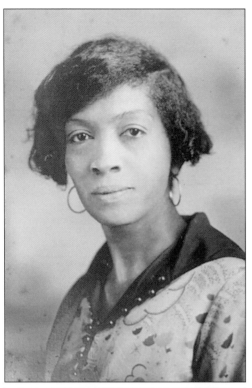

LOUISE PITTS BAILEY AND VERA PITTS SADLER.
The first two-year college normal
graduates, they completed their course
of study around 1920. The Pitts sisters,
natives of Boston, MA, finished their
standard high school education in Boston
and at the urging of Dr. Simon Green
Atkins came to Slater to matriculate
through the two-year normal program. The
normal curriculum was designed to make
students proficient teachers.

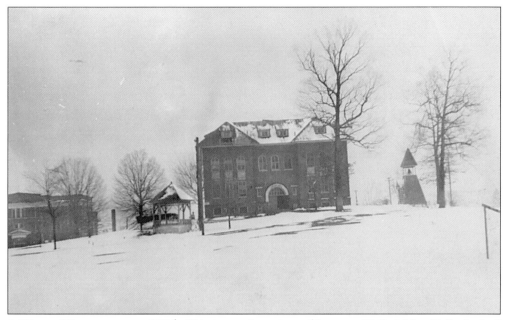

A WINTER WONDERLAND, c. 1924. This image is a view of Lamson Hall, Atkins Hall, the bell tower, and the gazebo after a snowfall on the Slater campus.

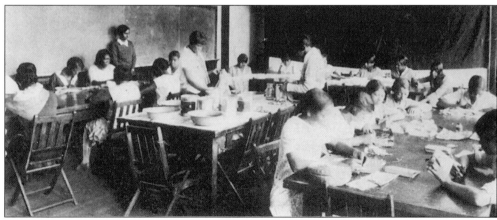

INDUSTRIAL ARTS CLASS, c. 1920. The industrial department provided training for men in carpentry, shoemaking, and agriculture. This picture shows a typical industrial arts class for females. These students would take classes in "sewing, cooking and general domestic economy."

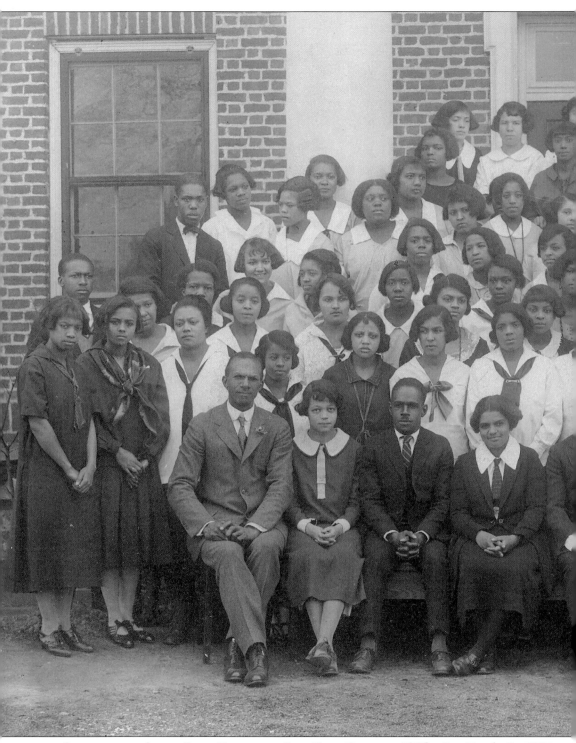

STUDENTS AND STAFF, FIRST YEAR AS A FOUR-YEAR COLLEGE, 1925. On March 7, 1925, the General Assembly of North Carolina ratified "An Act to change the name of the Slater Normal School at Winston-Salem to the Winston-Salem Teachers College and to

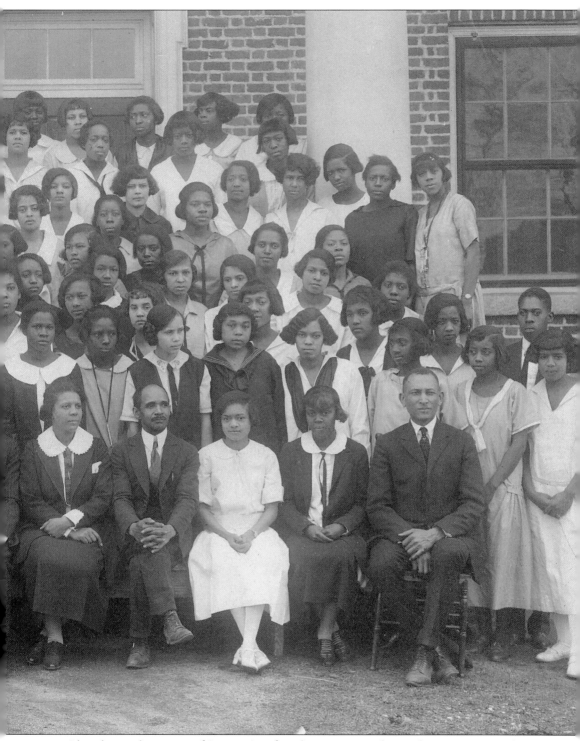

provide advanced courses of instruction for elementary teachers, elementary supervisors and principals."

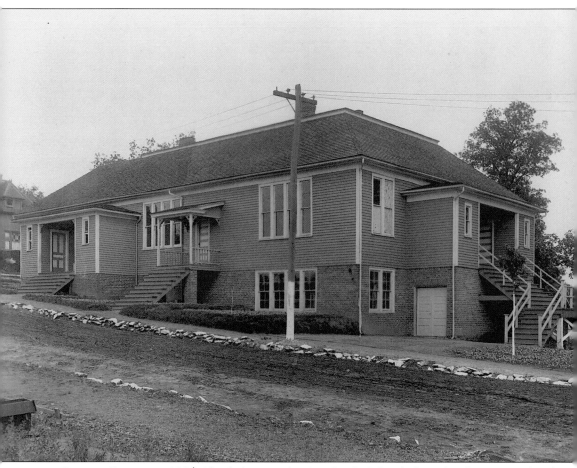

PRACTICE SCHOOL, *c.* **1914.** Also known as the City Grade School, this school accommodated seven grades and industrial education classes. The practice school, staffed by Slater faculty and students, provided Slater students with the opportunity to do their practice teaching in a monitored environment.

Two

CAMPUS LIFE

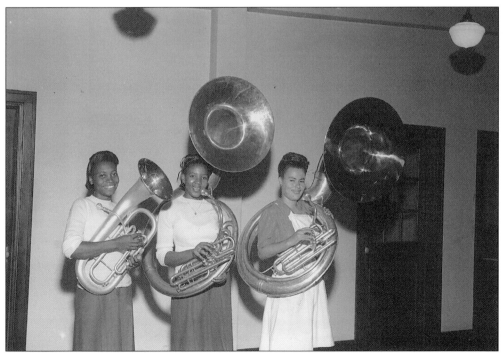

LADY BARITONE AND BASS HORN PLAYERS IN THE T.C. BAND, 1945. Pictured from left to right are Edith R. Hinnont from Fremont, NC; Lucille Joyner from La Grange, NC; and Addie Z. Speed from Snow Hill, NC.

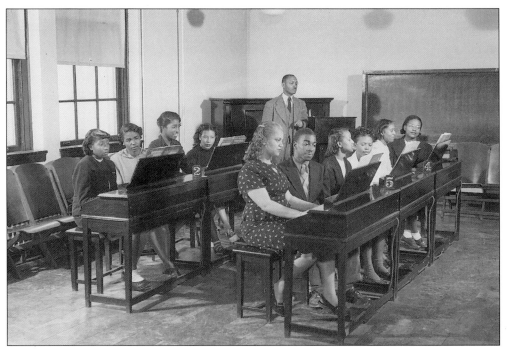

STUDENTS TAKING PIANO LESSONS IN FRIES AUDITORIUM, *c.* **1949.** Established in 1939, the Piano Music Department offered instruction to all Winston-Salem Teachers College students. In this picture students practice piano rudiments using the Ross Multiple Piano, which consisted of five remote keyboards and one upright master piano controlled by Dr. Dillard, the instructor.

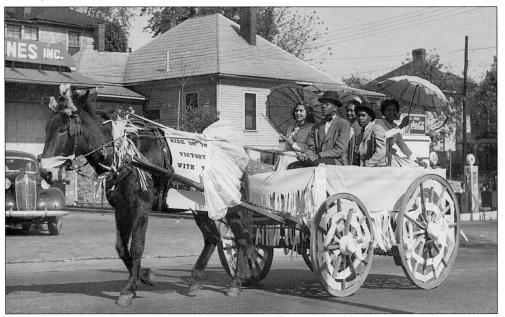

COLLEGE DANCE GROUP RIDES ON TO VICTORY IN HOMECOMING PARADE, 1945. Notice the horse-drawn cart. Pictured from left to right are the following: (front row) Vivian Hayes and Eddie Holmes; (back row) Ms. Johnnie Johnson, John Mason, and Alice Goode.

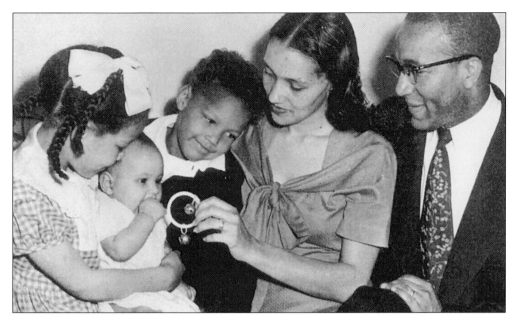

AFRICAN AMERICAN ADMITTED TO STATE MEDICAL SCHOOL, 1951. Pictured are Edward O. Diggs (Winston-Salem Teachers College graduate) and his family. Diggs was the first African American admitted to the University of North Carolina Medical School. The University of North Carolina is the oldest state university in America. Pictured from left to right are (children) Beverley Elise, Sharon Patrice, Edward, and (wife) Hazel.

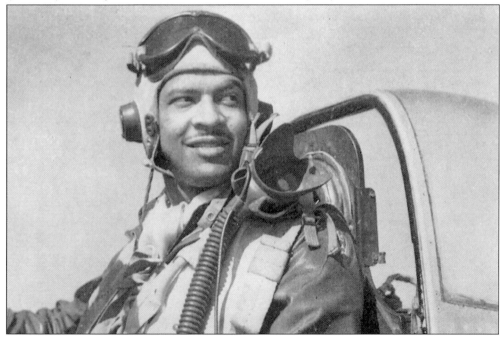

T.C. GRAD SERVES HIS COUNTRY, c. 1944. A member of the Colonel Benjamin O. Davis Jr. fighter group, First Lt. Spurgeon N. Ellington, Class of 1939, was awarded the Distinguished Flying Cross for damaging or destroying 80 enemy installations and supply trains in Southern Germany.

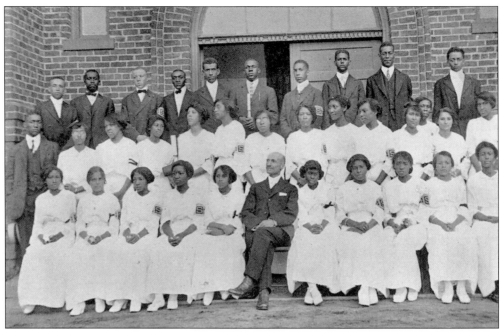

"S" Marks the Spot for Class of 1915. The "S" armbands worn by these Slater Industrial Academy and State Normal School students may be an official part of their graduation regalia.

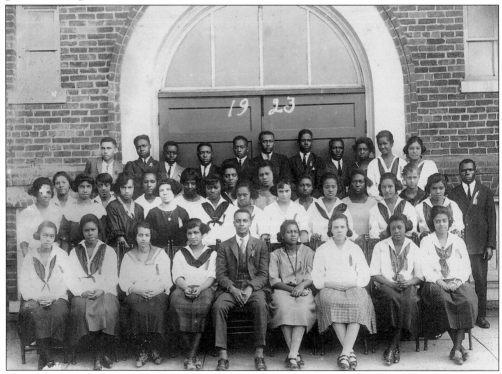

The Class of 1923. Francis L. Atkins, son of President Simon G. Atkins, sits in the front row in the middle of a group of students who would soon make their mark on the world.

32

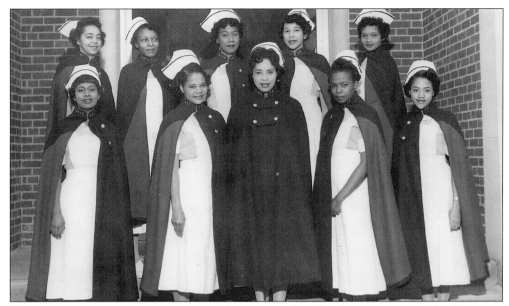

THE FIRST NURSING SCHOOL GRADUATES, 1957. As a result of the desire to improve healthcare in the state of North Carolina, in 1953 Governor William B. Umstead issued an executive order authorizing the establishment of a four-year collegiate nursing program at Winston-Salem State University. Pictured from left to right are the following: (front row) Bernice Davis, Ylene Veazie, Mary Scott, Betty Jean Brown, and Sadie Brown; (back row) Bertha Johnson, Jessie Herron, Barbara Hope, Shirley Caldwell, and Edna Taylor. Mary (Scott) Isom and Sadie (Brown) Webster later became faculty members of the nursing school.

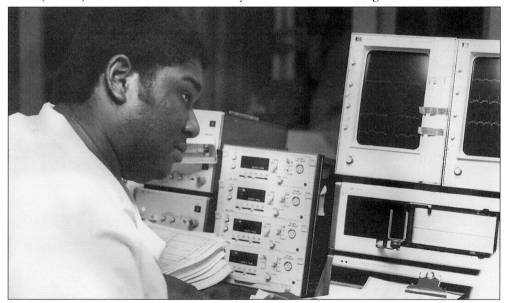

THE FIRST MALE TO GRADUATE FROM THE SCHOOL OF NURSING, 1977. In 1966, James E. Herbert, a licensed practical nurse, broke tradition when he became the first male to be admitted into the college's nursing program. Ten years later, Gilbert Hill completed the required course of study and became the first male to graduate from the nursing program with the B.S. degree.

KENNETH RAYNOR WILLIAMS, PH.D. (1961–1977). Upon his election as alderman for the city of Winston-Salem in 1947, he became the first African American in the state of North Carolina since Reconstruction to hold an elected political office. During his tenure as president of the college the curriculum and the physical campus were expanded. Williams's tenure also marked the transition from college to university and a constituent member of the University of North Carolina higher education system.

HAROLD DOUGLAS COVINGTON, PH.D. (1977–1984). A native of Winston-Salem, during his tenure as chancellor (all presidents in the University of North Carolina were designated as "chancellors") the student enrollment, racial integration, and faculty members with terminal degrees increased. Covington was the first chief administrator to undertake and exceed a capital fund drive of $1 million.

34

HAYWOOD LESTER WILSON JR., ED.D. (1984–1985). A 1963 graduate of Winston-Salem State University, he served as vice chancellor for student affairs prior to becoming interim chancellor. An advocate for student rights, Wilson was popular with students, staff, and faculty. Wilson Hall, a coeducational residence hall, was named in his honor.

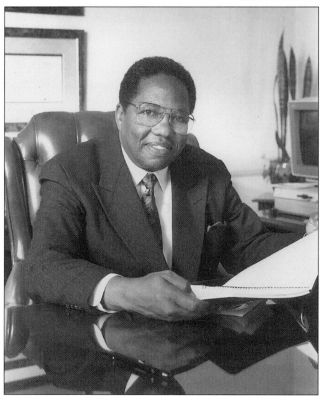

CLEON FRANKLIN THOMPSON JR., PH.D. (1985–1995). During his tenure a $25 million capital campaign was launched. He also initiated a scholarship program designed to boost the enrollment of academically talented students. The Cleon F. Thompson Student Services Center is named in his honor.

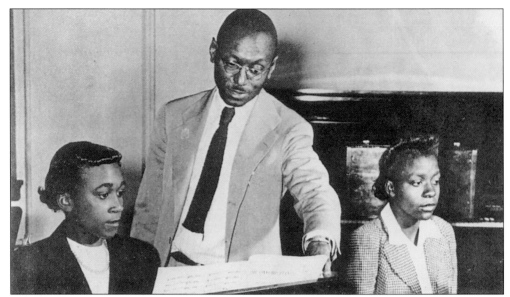

First Woman "G.I." and "Baby" of Freshman Class at T.C., 1946. Elizabeth Barker (left) was the first woman to register at Winston-Salem Teachers College (Winston-Salem State University) under the G.I. Bill of Rights. Along with Emanuline Jones (right), she was one of the youngest members of the 1946 freshman class. They are seen here taking piano instruction from Dr. James A. Dillard, director of music at the college.

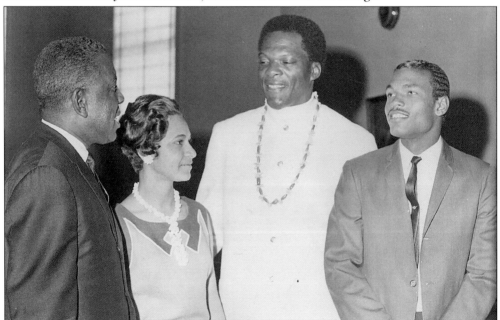

Students at Awards Day Program, 1968. Winston-Salem native Carl Eller of the National Football League's Minnesota Vikings delivered the Awards Day Program address. The Awards Day Program honors students, faculty, and staff who have been active in college activities and sporting events. Pictured from left to right are Kenneth R. Williams, president of the college; Joyce Everette; Carl Eller; and Lewis Turner, student government association president.

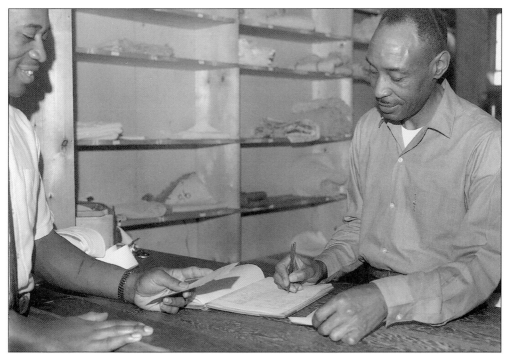

STUDENT AT CAMPUS LAUNDRY, 1965. Student Albert Roseboro gives a laundry ticket to supervisor Alexander E. Barber. At one time the university even provided a fold-and-press service.

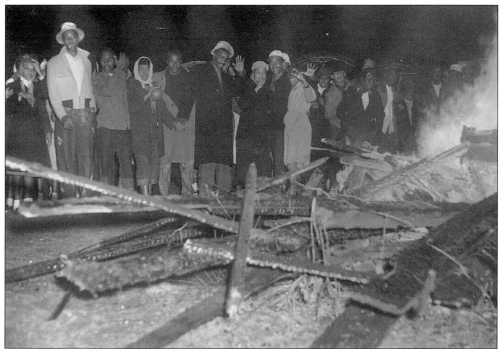

HOMECOMING BONFIRE, *c.* 1948. A long-standing tradition, students usually gathered around a fire for a celebration the night before the football game.

MALE STUDENT GRADUATES WITH B.S. DEGREE. James Webster was the first male student to graduate from Winston-Salem Teachers College (now Winston-Salem State University) with the Bachelor of Science Degree in 1928.

FIRST WHITE STUDENT RECEIVES A DEGREE IN 1968. Patricia Adams Johnson (Johansson) entered the college as an adult in the sophomore class in 1965. She graduated with the Bachelor of Arts Degree in English with honors in 1968.

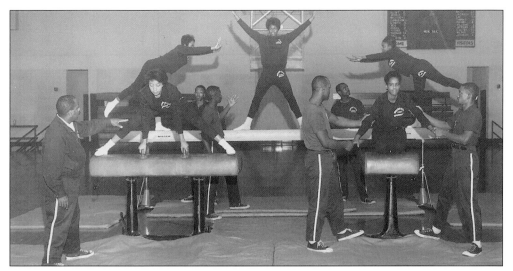

JOHN X. MILLER, ATHLETICS COACH AT THE COLLEGE TEACHES STUDENTS RUDIMENTS OF GYMNASTICS, c. **1965.** Miller's versatility and athletic knowledge enabled him to teach physical education classes as well as coach football at the university from c. 1959 to 1971.

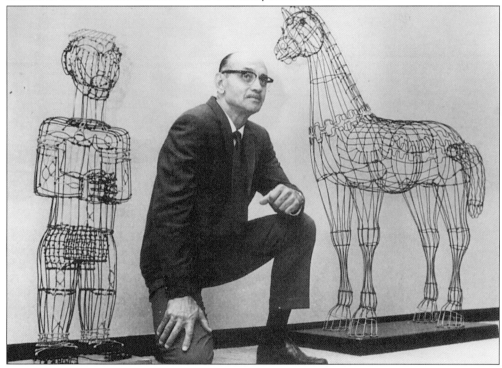

HAYWARD L. OUBRE, RENAISSANCE MAN, c. **1970.** Artist, former Winston-Salem State University Art Department chairman, and curator of the Selma Burke Art Gallery, Oubre is shown here with two of his wire sculptures. Pictured from left to right are *Pygmy* and *Young Horse.* These pieces were exhibited at Southern Illinois University through the cooperation of the Southern Illinois University Museum and the Winston-Salem State University exchange project. The creator of many complex and synergistic wire sculptures, Oubre also mastered color, sculpting, and the use of line in various mediums.

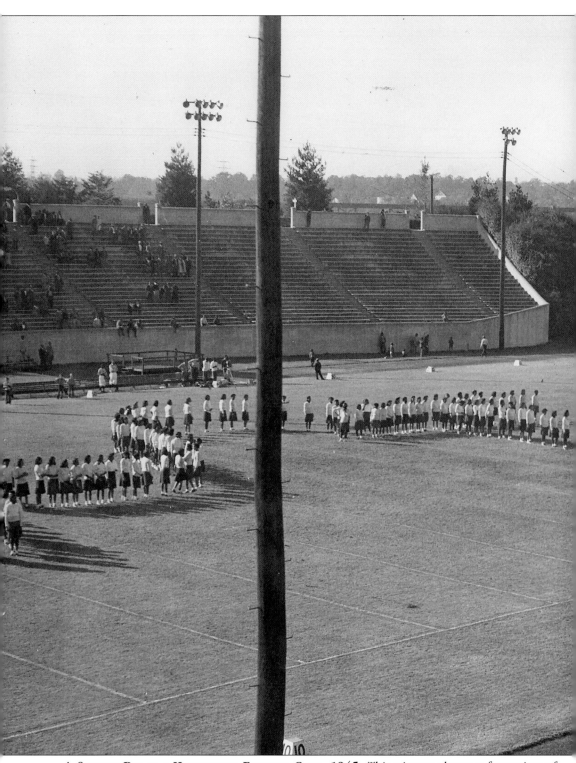

A Spelling Bee at a Homecoming Football Game, 1945. This picture shows a formation of freshman and sophomore physical education students during the halftime ceremonies of

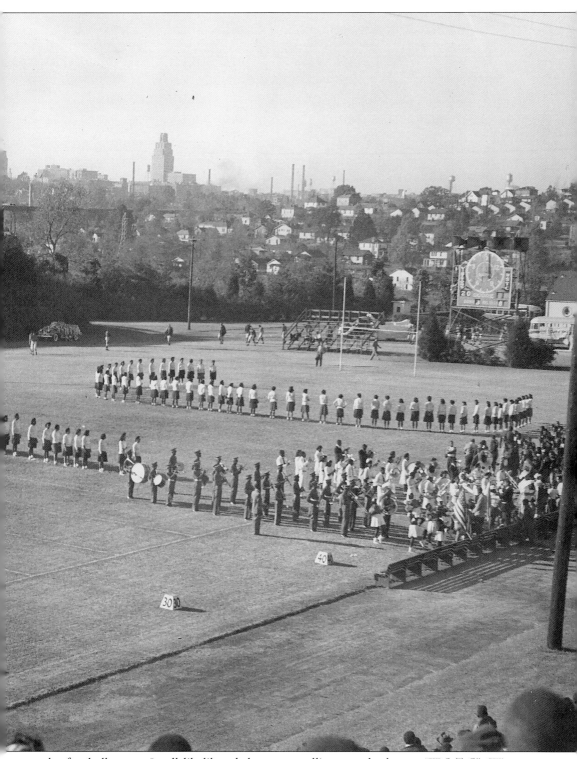

the football game. In all likelihood they are spelling out the letters "W S T C" (Winston-Salem Teachers College).

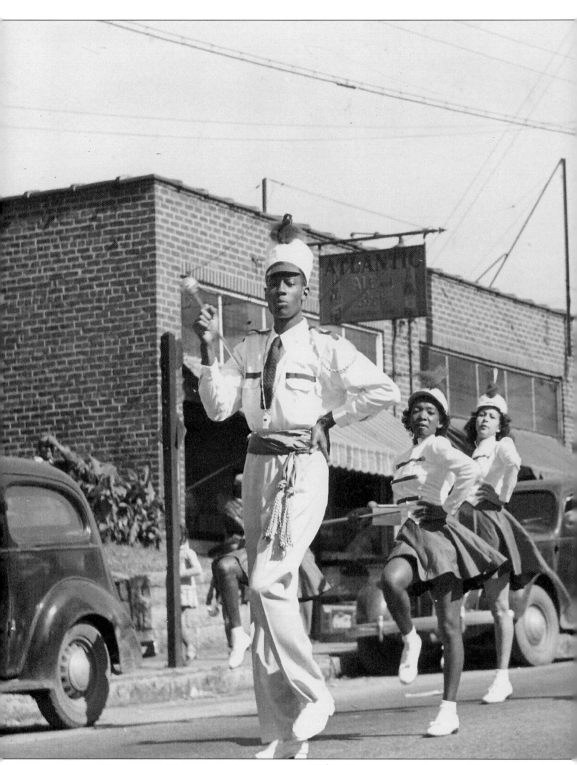

DRUM MAJOR AND MAJORETTES LEADING THE 1945 HOMECOMING PARADE. Pictured in the center is Romie Avery, drum major. From left to right are Mary O'Neil, Ann Reynolds,

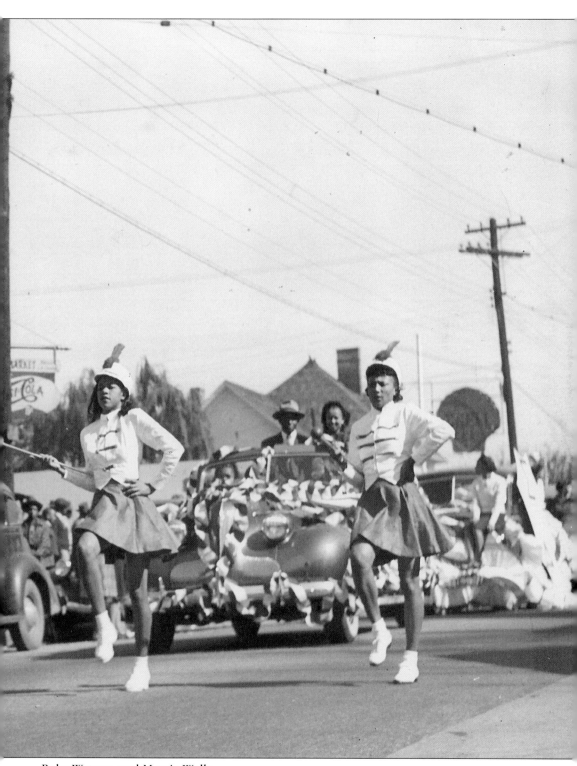

Ruby Watson, and Margie Wells.

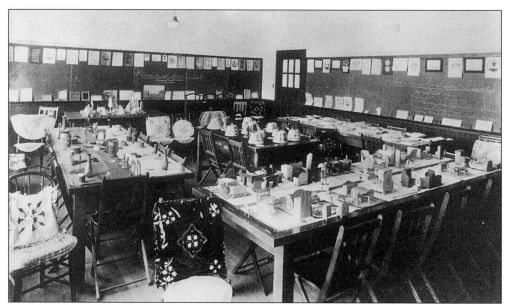

INDUSTRIAL ARTS EXHIBIT, *c.* 1929. Industrial arts classes were primarily meant to teach students about the production, history, and social uses of handicrafts and household items.

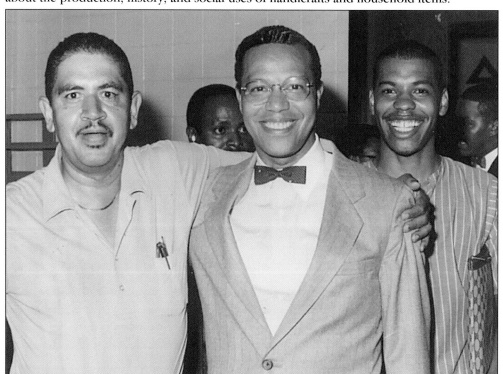

LOUIS FARRAKHAN RETURNS HOME, 1985. Formerly Eugene Walcott, he received a track scholarship and enrolled at Winston-Salem Teachers College in 1951. A talented violinist who sometimes sang with the college choir, he left school in 1953 to perform calypso music professionally. He joined Elijah Muhammad's Nation of Islam in 1955. Pictured from left to right are Beaufort Bailey, Louis Farrakhan, and Carl "Chip" Willis.

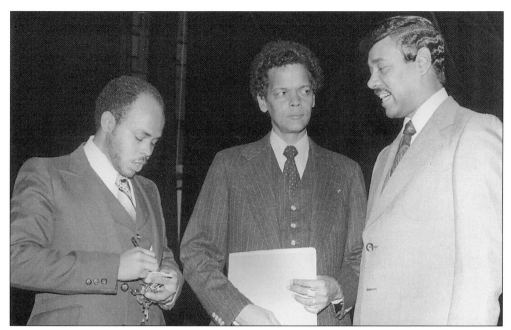

Georgia State Senator and Civil Rights Activist Julian Bond Speaks to Students, c. **1978.** Pictured from left to right are William Penn (student government association president), Julian Bond, and Dr. H. Douglas Covington (chancellor).

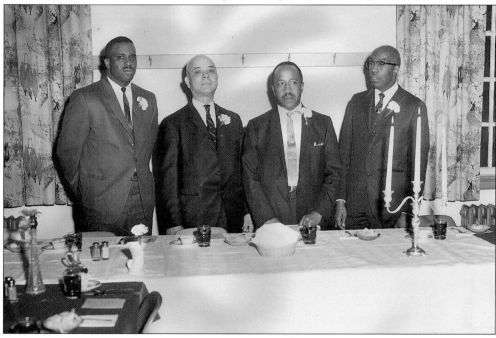

Campus Staff Involved in Mens Week Celebration, 1967. The purpose of Mens Week was to encourage and promote participation on the part of men in educational and recreational activities. Pictured from left to right are Rev. Henry Lewis (college chaplain), George Newell (dean of men), John W. Hauser (speaker for Mens Week), and Archie Blount (vice president of the college).

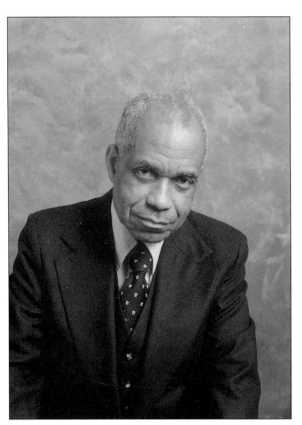

JOSEPH N. PATTERSON, PH.D. Known as "Dr. Pat" to his friends and students, he taught courses in philosophy and education from 1950 to 1978. One of his favorite mottos was: "Those who dare teach must never cease to learn."

RACHEL DIGGS WILKINSON, PH.D. SECRETARY OF ALUMNI RECORDS, c. 1967. A 1933 graduate of Winston-Salem Teachers College (Winston-Salem State University), she became the college's first director of alumni affairs when she was appointed secretary of alumni records in 1938. She was also instrumental in the forming of National Alumni Association on the Winston-Salem State University campus in 1946. This organization was made up of alumni associations from historically black colleges and universities.

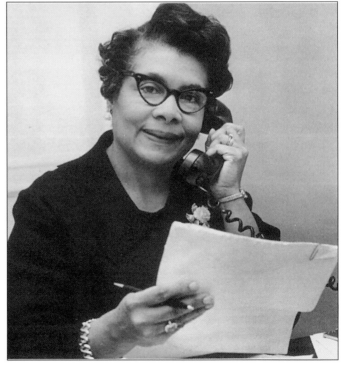

WINSTON-SALEM STATE UNIVERSITY PHYSICIAN, DR. H. REMBERT MALLOY (1954–1981). A physician and a surgeon, Malloy graduated from the Howard University School of Medicine in 1939, and did his internship at Kate B. Reynolds Memorial Hospital. He later became the college's physician, from 1954 to 1981.

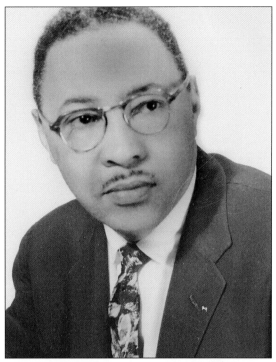

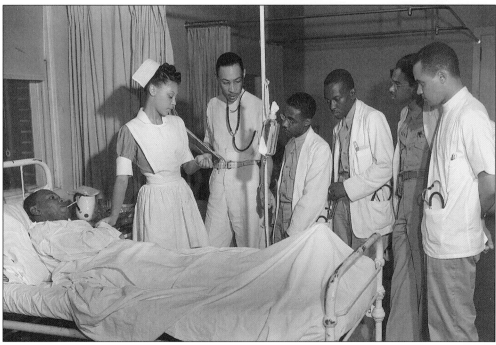

CHIEF RESIDENT INSTRUCTS INTERNS AT FREEDMEN'S HOSPITAL IN WASHINGTON, D.C., c. **1941.** A native of Winston-Salem, H. Rembert Malloy Sr. was a student and colleague of noted African-American doctor and blood plasma innovator Charles Drew. Malloy became the campus physician following the death of Dr. Alexander H. Ray in 1954. He is pictured third from the left.

47

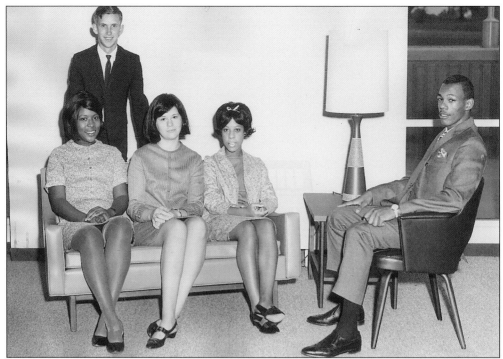

WINSTON-SALEM STATE UNIVERSITY AND SOUTHERN ILLINOIS UNIVERSITY EXCHANGE PROGRAM, *c.* **1966.** This program, started in 1965 under the federal government's Title III program, included student and faculty exchange, curriculum development, faculty study leaves, and opportunities for Winston-Salem State University students to obtain advanced degrees. Pictured from left to right are David Baggot (standing, SIU); Ruby McCallum (seated, WSSU), Ann Funderburk (SIU), Sandra Jenkins (WSSU), and Arthur Phillips (WSSU).

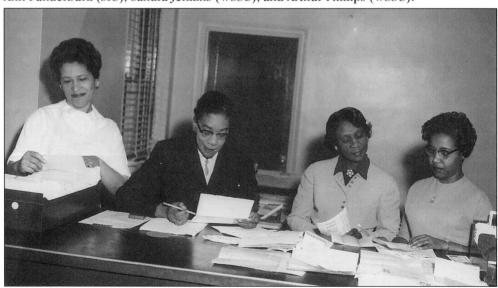

THE REGISTRAR CHECKS STUDENTS GRADES, *c.* **1962.** Frances Ross Coble served as secretary to the dean and registrar, and then as registrar from 1930 to 1974. In 1983 the university honored her with the title of Professor Emerita. She is pictured second from left.

STUDENT TRAVELS ABROAD FOR INTERNATIONAL EXPERIENCE, 1966. Sylvia Sprinkle (Hamlin) traveled with students from other American colleges to India as a participant in the International Living Program. She was the first student from Winston-Salem Teachers College (Winston-Salem State University) to participate in what is known today as a study-abroad program.

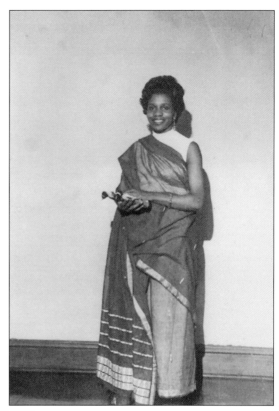

FUTURE ART INSTRUCTOR GIVES PRESENTATION, 1943. James T. Diggs, who would go on to teach art at Winston-Salem State University, makes some brief comments at the Winston-Salem Teachers College alumni business meeting. Carl "Chink" Martin, sitting in the chair adjacent to the speaker, looks on.

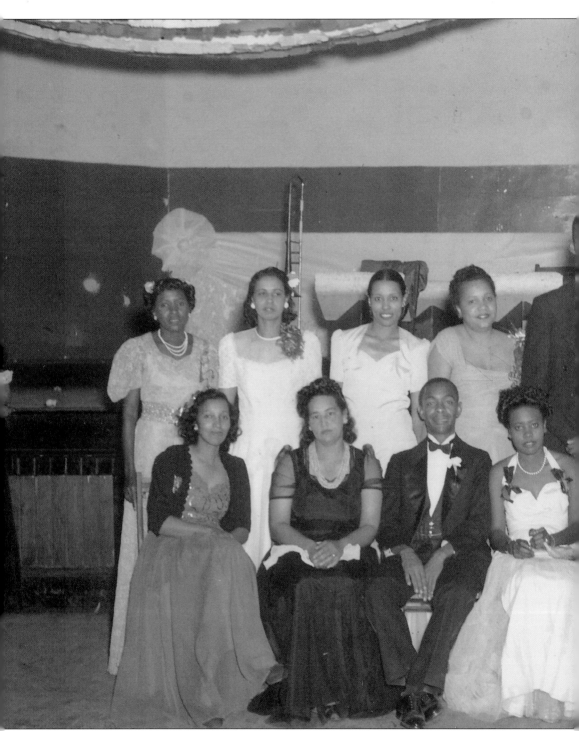

KIMBERLEY PARK ALUMNI CHAPTER, WINNER OF THE "GUEST CLUB" CONTEST FOR 1945 HOMECOMING.
Pictured from left to right are the following: (seated) Irene Pace Hairston, Viola Crosby McLean, Edward L. Patterson (president), Cleester A. Coleman, Viola Gregory Brown, Catherine Chester Humphrey, and Susie M. Speight; (standing) Lucretia Coleman Compton

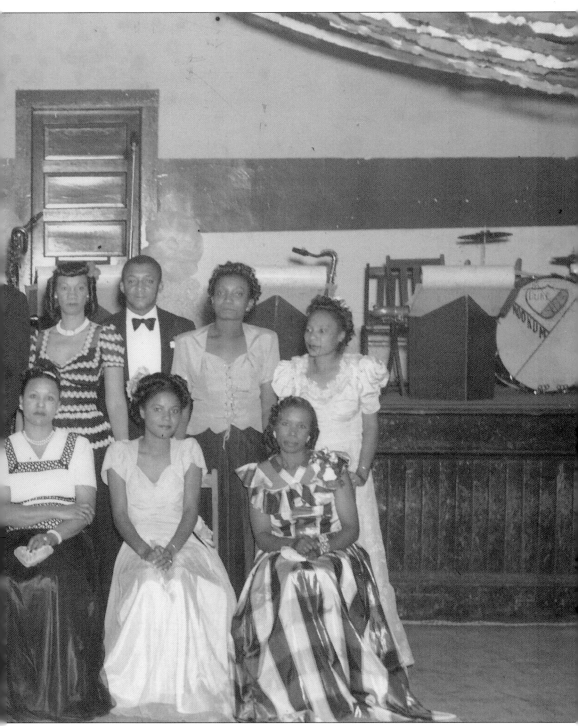

(treasurer), Rita Sitgraves Harris (vice president), Helen Powers Stevens, Douschka Osborne Penn, Andrew L. Yarborough, Alma E. Setzer (secretary), Lafayette A. Cook, Edna Cozzen Revels, and Ruthie Peoples Matthews.

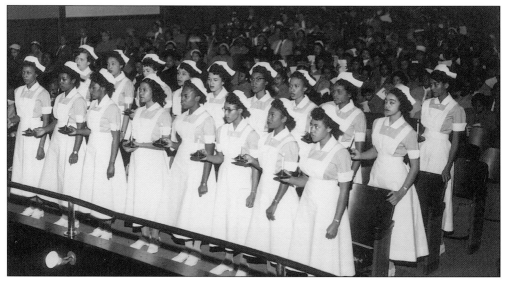

THE FIRST CAPPING CEREMONY AT THE COLLEGE, *c.* **1955.** These second-year nursing students designed their own caps, with three small pleats on each side in the back and fastened with a pearl button.

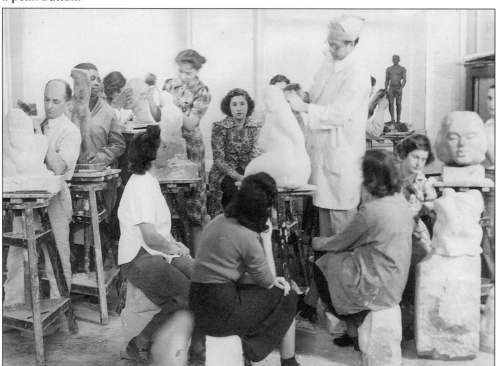

ARTIST SELMA BURKE IN SCULPTING CLASS, 1939. A graduate of Slater Industrial Academy and State Normal School (Winston-Salem State University), this picture shows famed artist Selma Burke studying sculpting at Columbia University. Burke is best known for her image of President Franklin Delano Roosevelt found on the dime. An art gallery named in her honor, housing her entire art collection, was once located on the Winston-Salem State University campus.

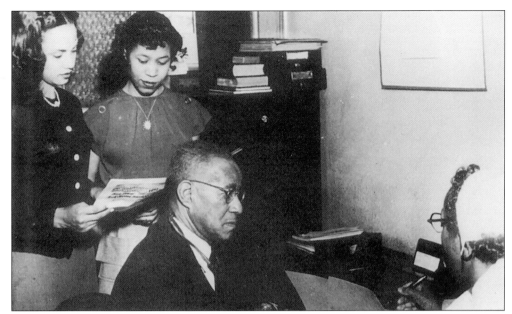

THE COLLEGE PHYSICIAN AND NURSE LOOK OVER SOME STUDENT MEDICAL RECORDS, 1951. Prior to becoming full time physician for the college in 1941, Dr. Alexander H. Ray and several other African-American medical doctors formed a private hospital to combat the racist practices of the day that denied African Americans health and employment opportunities. Mary Spencer was the university's first nurse from 1948 to 1962. Pictured from left to right are Marian Anderson, Carolyn Kennedy; Dr. Alexander H. Ray, and nurse Mary Spencer.

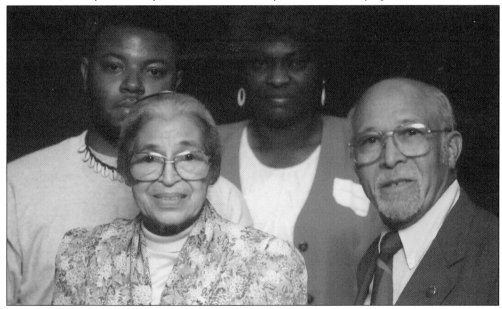

TWO CIVIL RIGHTS ACTIVISTS AND FREEDOM FIGHTERS MEET, c. 1995. Pictured from left to right are Rosa Parks and Charlie B. Hauser. Rosa Parks was instrumental in sparking the 1955 bus boycotts in Montgomery, AL. In 1947 Hauser (a Winston-Salem State University Alumnus) violated the Jim Crow law and was arrested in Mt. Airy, NC, for refusing to take a back seat on a passenger bus.

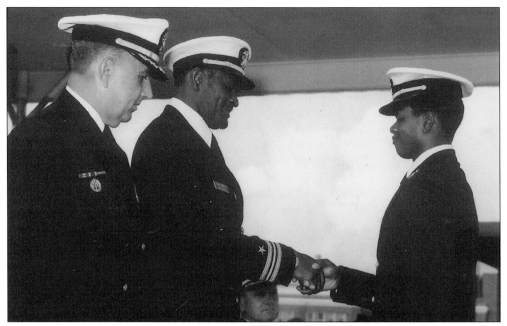

Naval Lt. Commander Joseph H. Daniels Sr. at Naval Aviation School Graduation, 1975. Over the years Daniels served Winston-Salem State University as recruiter, residence hall director, and director of housing. Pictured from left to right are Captain Phillip R. Craven, Joseph H. Daniels Sr., and officer candidate Roger Evon Burrell. Burrell is a graduate of Winston-Salem State University.

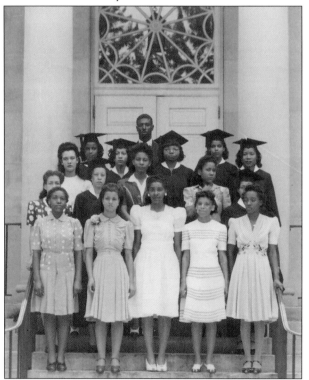

The Winners of Over $300 in Annual Commencement Prizes, 1943. Some of the categories for which the students were awarded cash prizes were understanding of race relations in Winston-Salem, the promotion of conservative and constructive citizenship, leadership and scholarship in the senior class, the best scrapbook, proficiency in English, and campus upkeep and beautification.

ABOVE: **RUFUS HAIRSTON, FIRST ALUMNI BOARD OF TRUSTEE MEMBER.** A graduate of the Slater Industrial Academy and State Normal School (Winston-Salem State University) class of 1914, he was a pharmacist by profession. The Governor of North Carolina, R. Gregg Cherry, appointed Hairston to the college's board of trustees.

TOP RIGHT: **MADIE HALL XUMA, INTERNATIONAL HUMAN RIGHTS ACTIVIST,** *c.* **1921.** A 1937 graduate of Winston-Salem Teachers College, she was married to Dr. Alfred B. Xuma, the first black medical doctor in apartheid-era South Africa, and former president of South Africa's liberation organization, the African National Congress (ANC). She was instrumental in forming the ANC's Women's League as well as YWCAs for blacks in South Africa.

BOTTOM RIGHT: **WINSTON-SALEM TEACHERS COLLEGE CLUB OF GASTONIA, 1934.** These graduates of Winston-Salem Teachers College made up the Gastonia, NC alumni chapter. Pictured from left to right are (seated) Minnie Blue, Annie Davis, and Novella Ramseur; (standing) Ella Murray Whitworth, unidentified, and Rosa Smith.

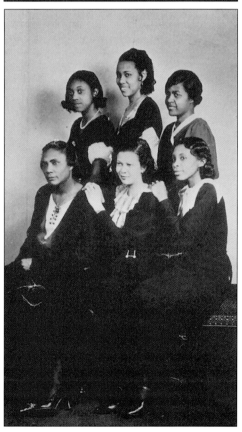

55

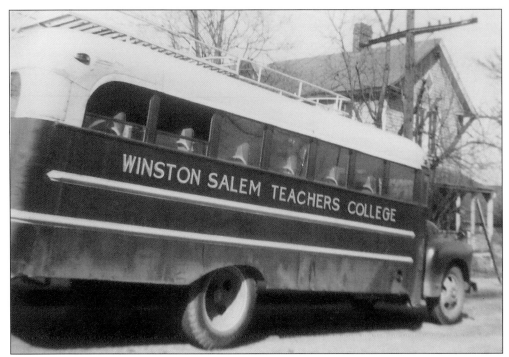

THE COLLEGE BUS, *c.* **1940s.** Archival documents and other photographs suggest that students doing their student teaching or participating in some other school activity such as football or basketball would probably be transported in this vehicle.

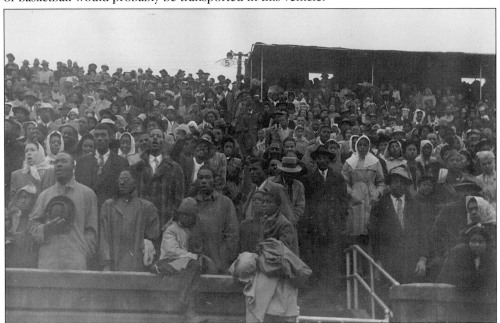

A CROWD AT A FOOTBALL GAME CHEERS ON THE HOME TEAM, *c.* **1948.** This group of people is pictured at Bowman Gray Stadium, the home field for the Rams of Winston-Salem State University. Some of the men have their hats off, suggesting they are probably singing the national anthem.

Three

ARCHITECTURE AND CAMPUS VIEWS

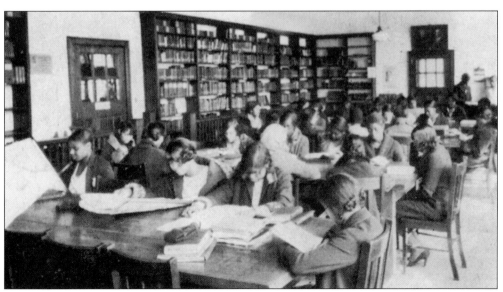

INTERIOR OF LIBRARY, *c.* 1933. This image shows students studying in the library, which was at one time located on the second floor of Carolina Hall. The library was moved to Blair Hall in 1940.

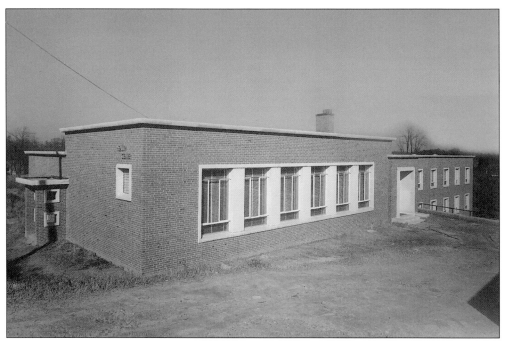

ALEXANDER H. RAY INFIRMARY AND HEALTH BUILDING. Completed in 1952, this building was named in honor of surgeon and campus physician Alexander H. Ray. It included space for medical and dental services, health classes, and a library.

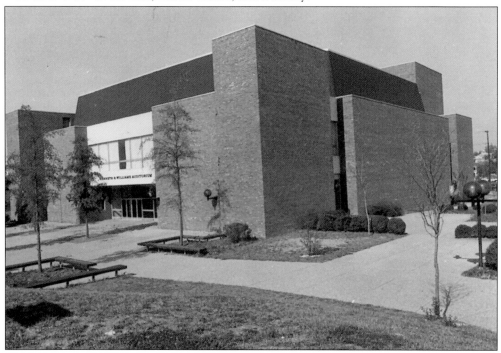

K.R. WILLIAMS AUDITORIUM. Constructed in 1975, this 1,800-seat facility replaced the old Fries Auditorium and is named in honor of Winston-Salem State University's fifth chief administrator.

MOYER HAUSER BUILDING. Constructed in 1971, this building was named in honor of Moyer M. Hauser. Hauser was a graduate of Slater and later worked at the college as an instructor and plant engineer. This building once housed the student union.

DILLARD HALL. Constructed in 1971, this three-story brick residence hall for female students was named in honor of educator and university trustee Nicholas L. Dillard.

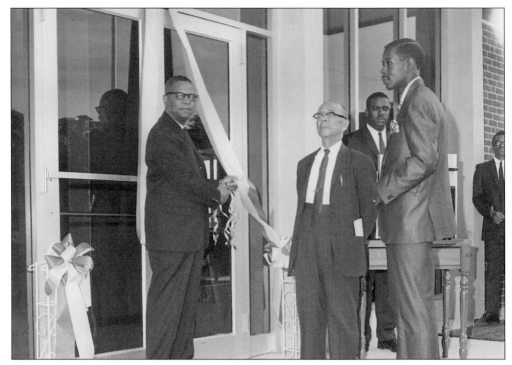

MR. THOMAS J. BROWN PARTICIPATES IN DEDICATION SERVICE OF BUILDING NAMED IN HIS HONOR, 1966. T.J. Brown graduated from Slater Industrial Academy and State Normal School's academic postgraduate department in 1902. He later served as the principal of the practice school associated with the Slater school. Over the years he served the college as an instructor, administrator, and postmaster. Pictured from left to right in the foreground are Clark Brown, Thomas J. Brown, and Melvin Mayo (Student Government Association President).

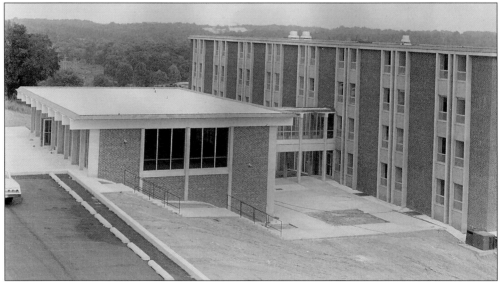

BROWN HALL. Completed in 1966, this five-floor residence hall for male students was named in honor of former Winston-Salem State University faculty member Thomas J. Brown.

60

FINE ARTS BUILDING. Completed in 1958, this two-story brick structure was designed for use by the music and art programs.

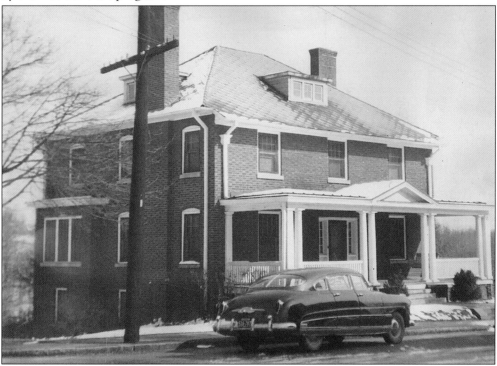

PRESIDENT'S HOUSE. Originally one of the residences of Simon Green Atkins, this structure was built in 1924. It currently houses the office of Alumni Affairs.

Carolina Hall. Completed in 1925, this three-story structure was named in honor of the state of North Carolina. It originally housed the president's office and boardroom, administrative offices, library, bursar's office, and science laboratories. It was renovated in 1954.

F.L. Atkins Building. Completed in 1983, this building houses the Division of Allied Health, and was named in honor of university president Francis. L. Atkins.

PHYSICAL PLANT BUILDING. Constructed in 1975, this building houses administrative offices for facilities management, housekeeping, maintenance, and grounds.

C.E. GAINES CENTER. This athletic facility has a gymnasium for basketball and volleyball, an Olympic-size swimming pool, weight rooms, classrooms, administrative offices, and training rooms. Completed *c.* 1976, this structure was named in honor of legendary Winston-Salem State University athletic coach Clarence E. "Bighouse" Gaines.

Hill Hall. Completed in 1965 this structure houses the programs for life and physical sciences. This building was named in honor of James S. Hill, an educator and banker. During the college's formative years in the 1890s, Hill traveled to various northern states soliciting financial donations for the college.

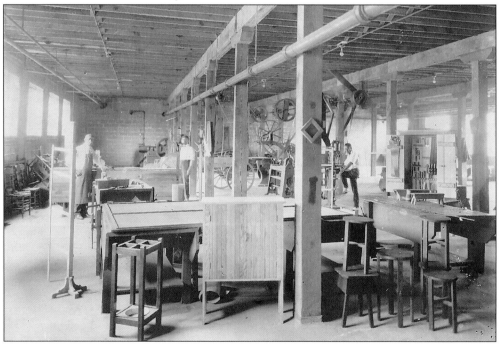

Inside the Shop, c. 1932. This shop was located in the basement of the first gymnasium. An interior view shows the workshop used by students and school workmen such Handy Whitworth. A master carpenter, Whitworth was said to be able to fix anything. He was employed at the college from c. 1929 to 1965.

FRIES AUDITORIUM. Built in 1939, this building was named in honor of longtime trustee and businessman Henry E. Fries. Torrential rains caused the roof to collapse in 1970. The building was eventually demolished.

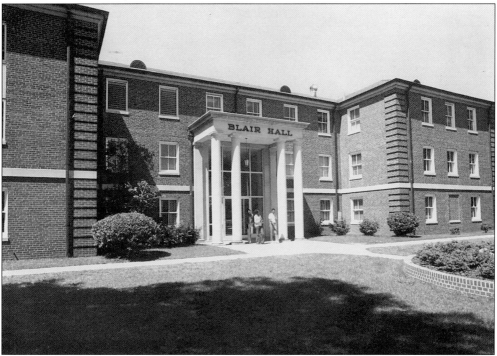

BLAIR HALL. Completed in 1940 to accommodate the college's administrative offices, this three-story structure was named in honor of Winston-Salem banker and college trustee William A. Blair.

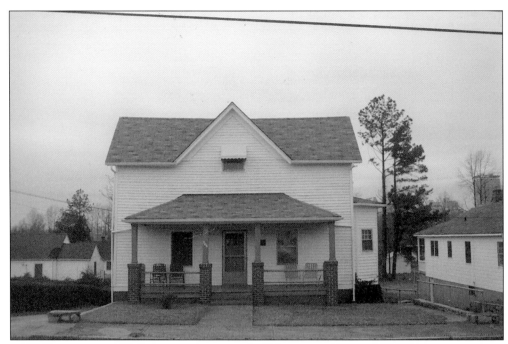

COLUMBIAN HEIGHTS RESIDENCE OF THE PRESIDENT. This dwelling was once occupied by Dr. Simon Green Atkins at the formation of the Columbian Heights community in 1891. This structure was designated as a historic landmark and placed on the National Historic Register *c.* 1977–78.

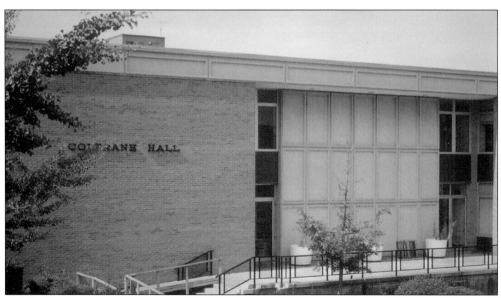

COLTRANE HALL. Built in 1967 to house the education and social sciences programs, this structure was named in honor of North Carolina State Budget officer David S. Coltrane.

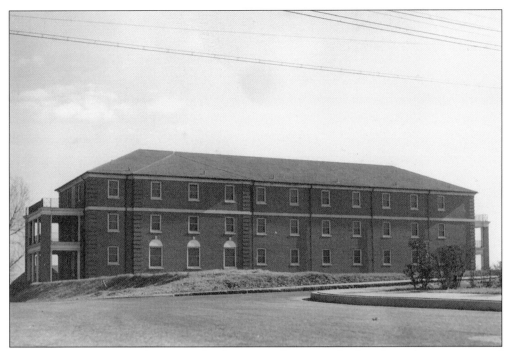

PEGRAM HALL. Constructed *c.* 1937, this four-story dormitory for female students was named in honor of Oleona Pegram Atkins, wife of President Simon G. Atkins. This building currently houses the physical therapy program, and provides residence space for a small number of students.

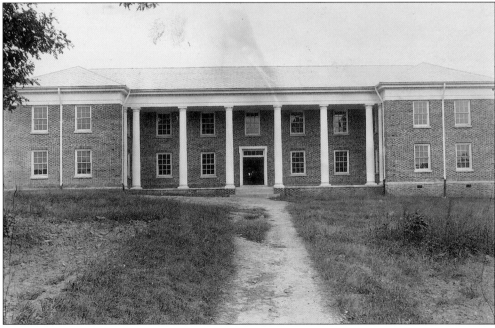

BICKETT HALL. This building was constructed *c.* 1921 and named in honor of North Carolina governor Thomas W. Bickett. Additions were added to the original building in 1929 and 1952.

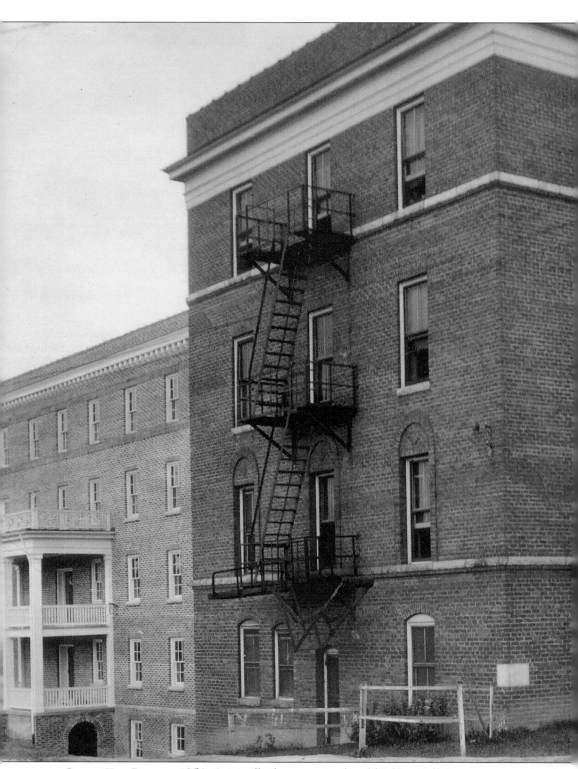

COLSON HALL PRIOR TO 1952. Originally the annex to the old Atkins Hall, it was renovated and named in honor of Kate D. Colson in 1952. Colson was a longtime instructor and dormitory

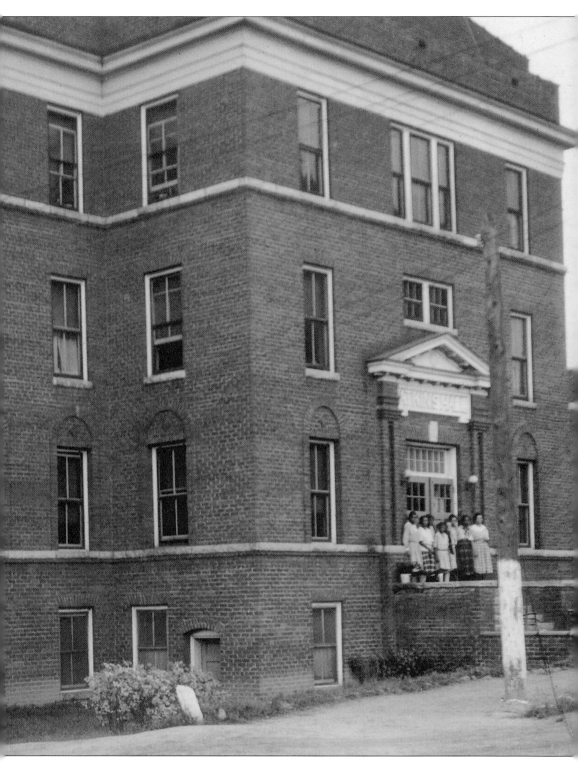

matron at Slater Industrial Academy and State Normal School. This is a picture of the annex attached to old Atkins Hall prior to being renamed Colson Hall.

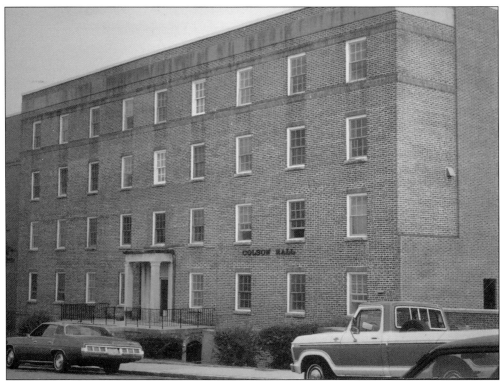

COLSON HALL IN THE 1970s. Named in honor of former dormitory matron Kate Colson, this building provided housing accommodations for female students until it was deemed uninhabitable in 1988.

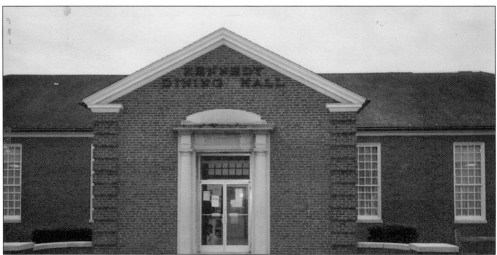

KENNEDY DINING HALL. This building was completed in 1939 and named in honor of Mayme Kennedy, longtime dormitory supervisor and wife of President Marion Francis Kennedy. The building was demolished in the early 1990s to make way for the Thompson Student Services Center.

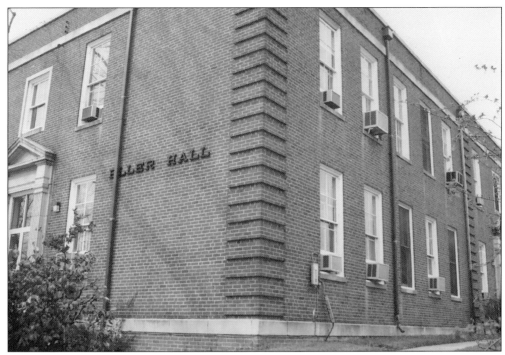

ELLER HALL. This building was constructed in 1938 and named in honor of Adolphus H. Eller, attorney and board of trustee member. This structure once provided space for all science classes and laboratories.

HOME ECONOMICS BUILDING. This building was constructed in 1918 and was originally known as the Science Hall and Industrial Arts Building. It later housed the home economics program. In 1953, the building was remodeled and used by the offices of Alumni Affairs and Public Relations; it was later known as the Alumni Building.

71

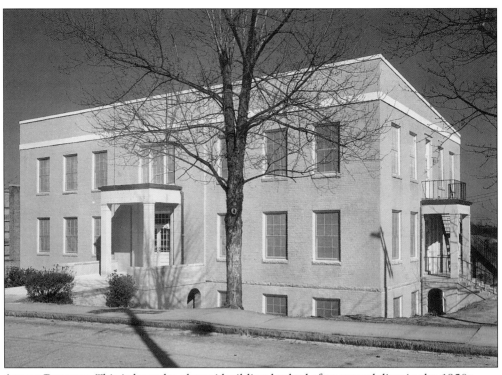

Alumni Building. This is how the alumni building looked after remodeling in the 1950s.

Old Atkins Hall. Built in 1915 as a dormitory for women, this brick structure was named in honor of President Simon G. Atkins. This building was demolished in 1984.

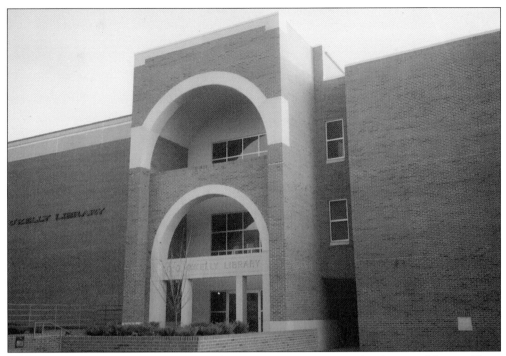

C.G. O'KELLY LIBRARY. Completed in 1967 this building was named in honor of former Slater Industrial Academy and State Normal School (Winston-Salem State University) president Cadd Grant O'Kelly. From 1940 to 1966, the library was housed on the second floor of Blair Hall. Additions to the 1967 structure were made in 1971 and 1989.

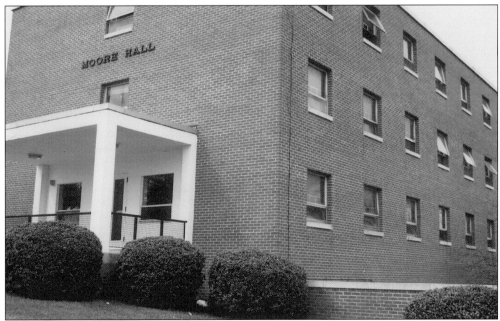

MOORE HALL. A dormitory for females built in 1965, it was named in honor of C. Beatrice Moore. A graduate of Slater Industrial Academy and State Normal School, she served as college dietician for many years.

Old Nursing Building. This structure was completed in 1956 and originally housed the nursing program. It now houses the Occupational Therapy program and the Athletics Office.

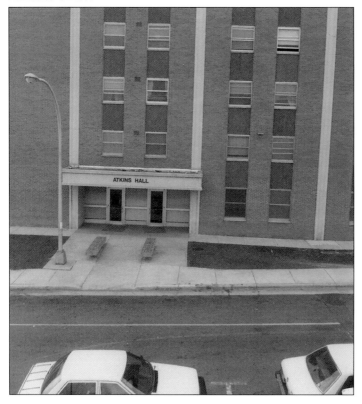

New Atkins Hall. This high-rise dormitory for women was completed in 1978. It took the place of the old Atkins Hall that was named in honor of university founder Simon G. Atkins.

HALL-PATTERSON COMMUNICATIONS BUILDING. Completed in 1978 this building was named in honor of former Winston-Salem State University professors George H. Hall and Joseph L. Patterson. This building houses the departments of English and Foreign Languages and Mass Communications.

R.J. Reynolds Center. Built in 1984, this building houses the School of Business and the Academic Computing Center. This structure was named in honor of Winston-Salem tobacco magnate R.J. Reynolds.

Albert H. Anderson Center. Originally a junior high school, this property was purchased from the Forsyth County School System in 1981. It was named in honor of Albert H. Anderson, a local educator who often taught summer school at Winston-Salem State University.

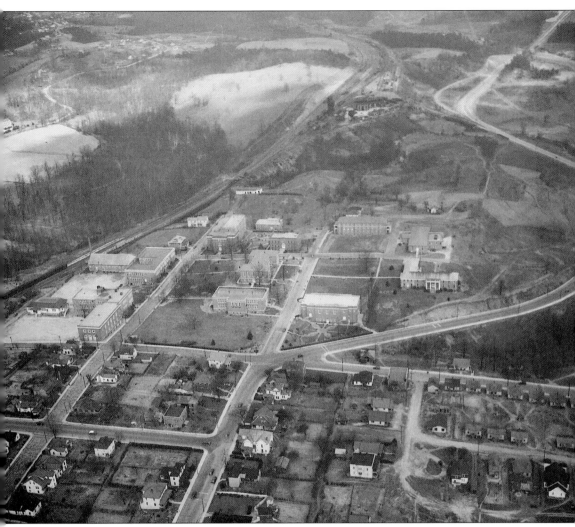

AERIAL VIEW OF CAMPUS AND SURROUNDING COMMUNITY, *c.* **1940s.** This picture shows the college campus and the local community bordering its periphery.

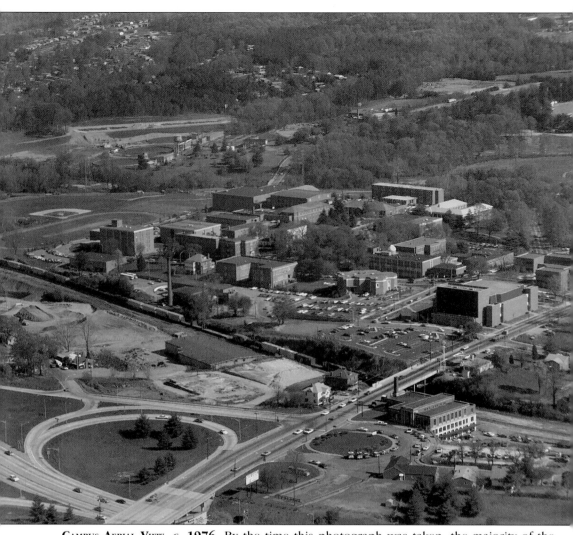

Campus Aerial View, c. 1976. By the time this photograph was taken, the majority of the buildings currently on the campus had been constructed. Ten years later more construction was undertaken on the campus's western periphery to facilitate an expanded curriculum and growing student population.

Four

ATHLETICS

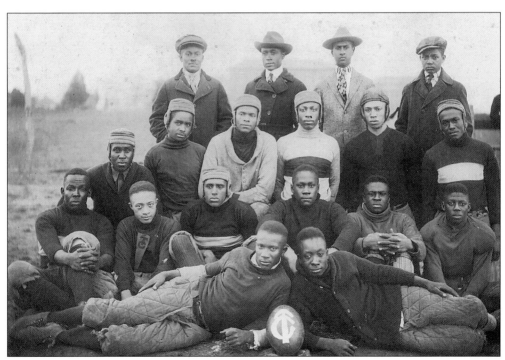

AN EARLY WINSTON-SALEM TEACHERS COLLEGE FOOTBALL TEAM, c. 1926. Football during this time at the college was largely informal and played on an intramural or club level. Formal intercollegiate football was not played at the college until the 1940s.

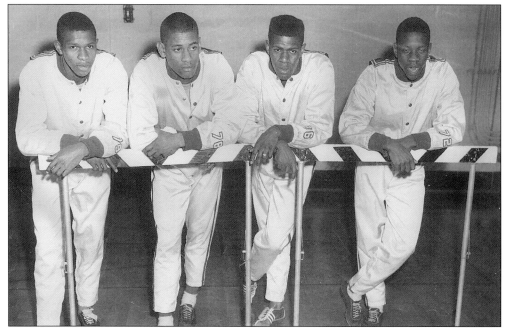

PENN RELAYS 480-YARD SHUTTLE HURDLE TEAM, 1957. Winston-Salem State University was the first small college and/or historically black college to win this event at the Penn Relays. This team's winning time in the event was 59.8 seconds. Pictured from left to right are Joe Middleton, Francis Washington, Elias Gilbert, and Carl Brown.

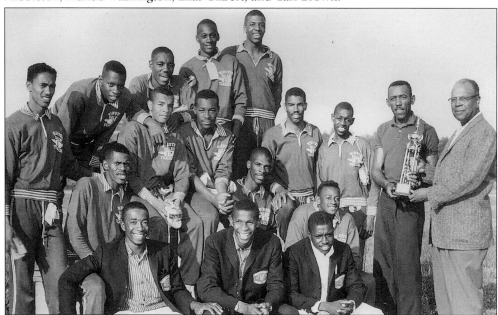

CENTRAL INTERCOLLEGIATE ATHLETIC ASSOCIATION TRACK AND FIELD CHAMPIONS, c. 1959. Pictured from left to right are the following: (front row) Frank Bowens, Joseph Middleton, Herbert Conaway, and unidentified; (middle row) Elias Gilbert, Godfrey Moore, Archie Brooks, Edward Riley, Charles Lewis, Joe Rouse, Coach Wilbur Ross, unidentified; (back row) Russell Rogers, Carl Brown, Robert Manning, Dwight Gardner, and Robert Jackson.

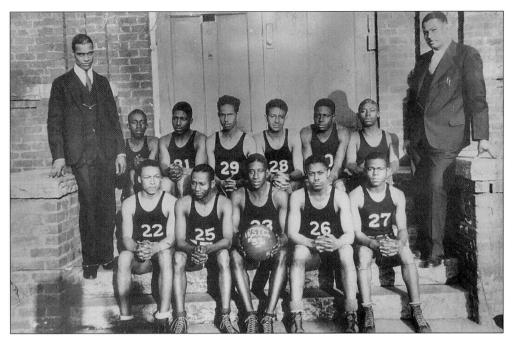

THE FIRST COLLEGIATE BASKETBALL TEAM AT TEACHERS COLLEGE, 1932. At the time of this picture, basketball was in its infancy at Winston-Salem, much unlike the fast-paced game the school would later be known for. Basketball games during this time might be played in a gymnasium with a low ceiling, a cafeteria, or outdoors. Pictured from left to right are as follows: (front row) James Diggs, Walter Gray, Robert Schooler, William Roscoe Anderson, and Belvedere N. Cook; (back row) Hunter Johnson (coach), James Boyd, Theodore Hayes, Robert Scales, Jesse Eggleton, Theodore Staplefoot, Rupert Bell, and A.W. Simon (manager).

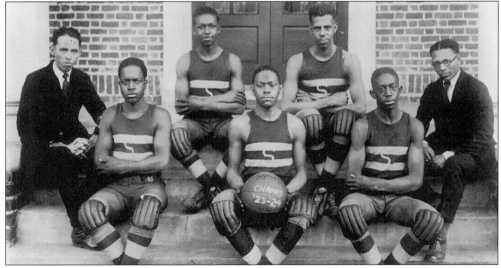

SLATER "STAR" BASKETBALL TEAM, 1923–24. This team was undefeated, and played schools such as N.C. A&T College, Lutheran College, Charlotte High, and Winston-Salem Junior High School. The defeat of the college teams was remarkable, because all of the Slater players were from the high school department.

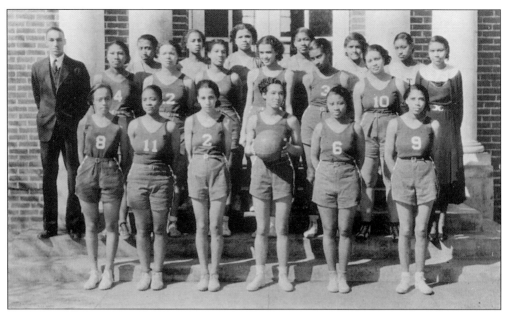

WINSTON-SALEM TEACHERS COLLEGE WOMENS BASKETBALL TEAM, 1935. The 1935 team had a record of 4-3. Coached by Harold Taylor, the players were primarily underclassmen. Ten of the team's seventeen players were freshmen.

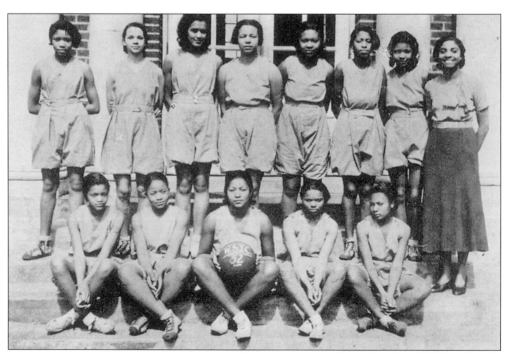

WOMEN'S ROUNDBALL AT TEACHERS COLLEGE, 1932. From the very beginning, female athletics at Winston-Salem State University have been as significant to the school as the male athletic teams. This may be one of the first female basketball teams.

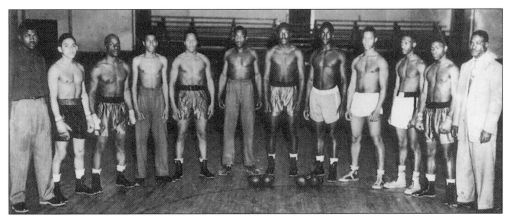

"Let's Get Ready to Rumble!" Boxing Team, 1952. Boxing came to Winston-Salem Teachers College (Winston-Salem State University) as a result of World War II military veterans returning to school to complete their formal education. Gwyndell Paige, a veteran enrolled at the college, was one of the first boxing trainers and coaches on the campus. Pictured from left to right are Frank Wiggins, Calvin Auten, Earl Jones, Lawrence Hauser, Wardlow Hall, James Graham, Clyde DeBerry, Herbert Hope, Benjamin Hall, Arthur Page, Wallace Green, and James. O. Sumler (trainer).

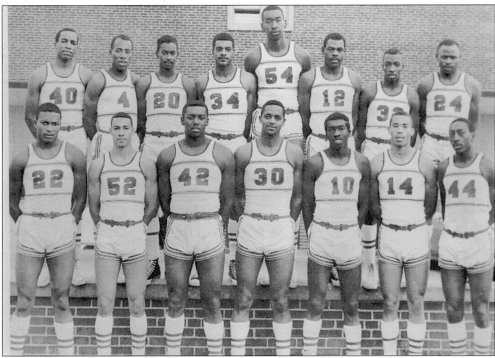

NCAA Division II Basketball Champions, 1967. The 1967 team was the first team in NCAA history from a historically black college or university to win a national championship. This team featured the nation's scoring leader Vernon Earl "The Pearl" Monroe. He averaged 40-plus points per game. Pictured from left to right are the following: (front row) Johnny Watkins, Allan McManus, William English, James Reid, V. Earl Monroe, Donald Williams, and Eugene Smiley; (back row) unidentified, Steve Smith, D. Green, Frank Hadley, Johnathan Latham, Ernest Brown, unidentified, and Vaughn Kimbrough.

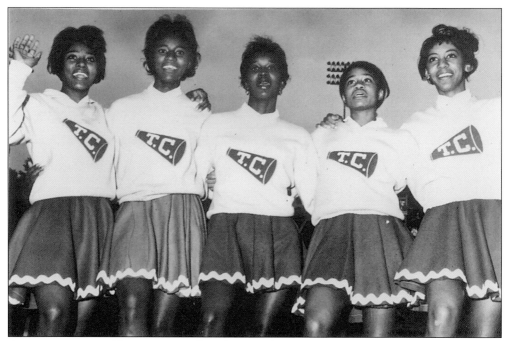

CHEERLEADERS HELP TEAMS WIN, 1963. Cheerleaders have always been an integral part of athletics and fan morale at Winston-Salem State University. At football games, basketball games, or in front of the marching band in parades, they keep Ram spirit going.

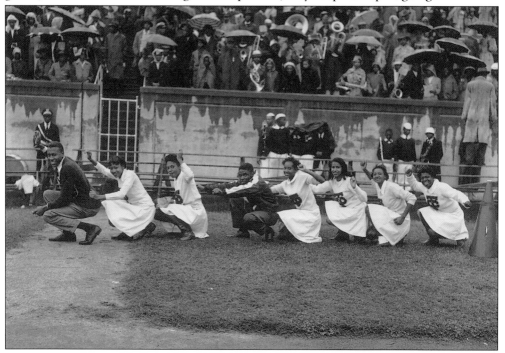

RAH, RAH, RAH GO RAMS! 1946. These enthusiastic cheerleaders at Bowman Gray Stadium, pictured from left to right, are Samuel Spencer, Mable Johnson, Annie Joyner, Lawrence Brown, Dorothy Thombs, Bernice Thompson, Sara Merritt, and Dora Dickerson.

Coach Howard K. "Brutus" Wilson, 1944. A graduate of Morgan State College, Wilson taught physical education classes and coached football and basketball at Winston-Salem Teachers College (Winston-Salem State University) from 1942 to 1946. Although football was a relatively new sport at the college, Wilson's 1942 squad was competitive enough to be asked to play in the Flower Bowl in Jacksonville, FL.

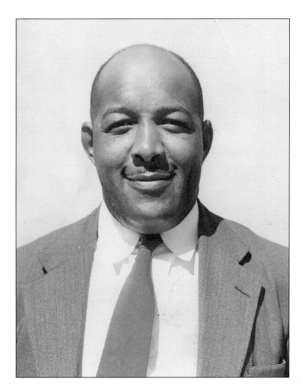

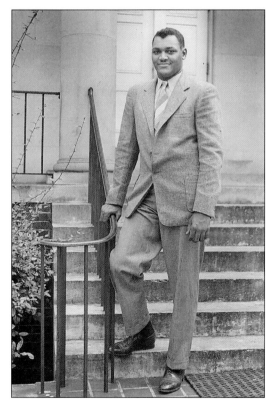

Clarence E. "Bighouse" Gaines, c. 1945. The fourth-winningest basketball coach in NCAA history with a record of 828-446, Gaines came to the college in 1945 as an assistant to Brutus Wilson. Known primarily as a basketball coach, his 1946 Rams football team posted an 8-1 record, making it the most successful team in the school's history.

85

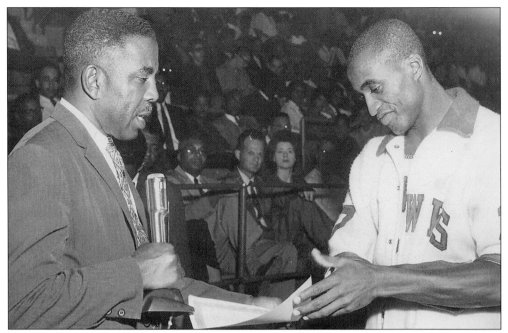

CLEO HILL, *c.* 1961. A three-time all-CIAA performer, Hill helped the Rams win the Central Intercollegiate Athletic Association basketball championship in 1961. He became Winston-Salem State University's first National Basketball Association player when he was selected number one by the St. Louis Hawks. In September of 1961, Hill returned to Winston-Salem for an exhibition game between the Hawks and the Philadelphia Warriors. Hill scored 21 points to help the Hawks win. This picture shows (left to right) President K.R. Williams and Cleo Hill.

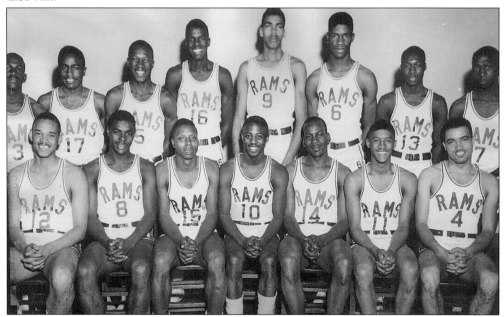

THE FIRST CIAA BASKETBALL CHAMPIONSHIP TEAM, 1953. The Rams would win a total of eight CIAA basketball championships from 1953 to 1977.

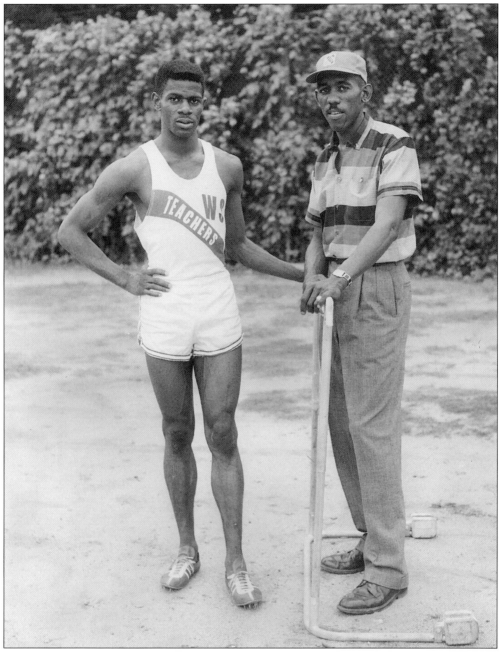

WORLD RECORD HOLDER AND HIS COACH, *c.* **1957.** A track and field innovator known as a coach who helped develop champions, Ross (right) authored a definitive work on hurdling, *The Hurdlers Bible*, in 1966. Ross coached track at Winston-Salem Teachers College (Winston-Salem State University) from 1952 to 1959. Elias Gilbert (left) competed for the Rams track team from 1955 to 1959, and set world records in the 120-yard high hurdles and the 220-yard low hurdles (around the turn).

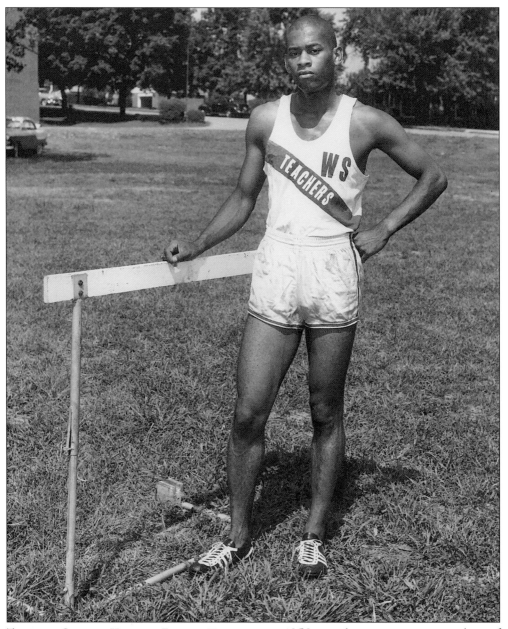

TEACHERS COLLEGE HURDLER FRANCIS WASHINGTON, 1958. Washington was a member of the track team from 1956 to 1960. Between 1956 and 1959 he accumulated three American collegiate records: the American record in the 440-yard hurdles, the national AAU 220-yard low hurdles record, and the Central Intercollegiate Athletic Association 220-yard low hurdles.

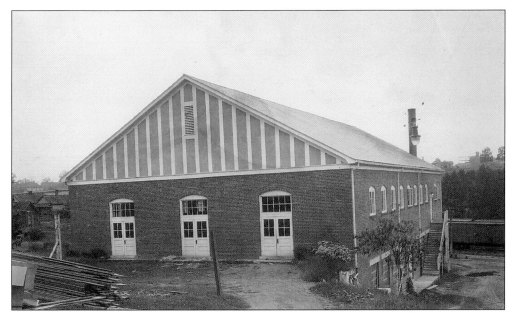

THE GYMNASIUM AND SHOP, *c.* **1928.** This building was the first sports complex on the campus. It was used for a multitude of events, ranging from basketball games to chapel services. The facility had a maximum seating capacity between 750 and 780. The earliest records indicate the 1924 Slater basketball team's games were routinely filled to capacity. In the basement of the gym was a large workshop for students taking industrial courses.

WHITAKER GYMNASIUM. Constructed in 1953, this building was named in honor of Winston-Salem businessman and Winston-Salem Teachers College Board of Trustee member John C. Whitaker. In addition to serving as an arena for basketball, volleyball, and physical education classes, there was classroom space for health education.

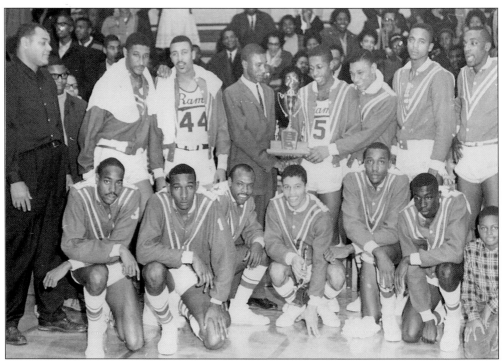

Tournament Winners, 1964. The team pictured here won the Georgia Invitational Tournament. Pictured from left to right are the following: (front row) Ted Ratchford, Thomas Cunningham, Charlie Simmons, Theodore Blunt, Willis Bennett, and Earl Monroe; (back row) Coach Clarence E. Gaines, Louis Parker, Richard Glover, Willie Curry, Richard Smith, James Reid, and Gilbert Smith.

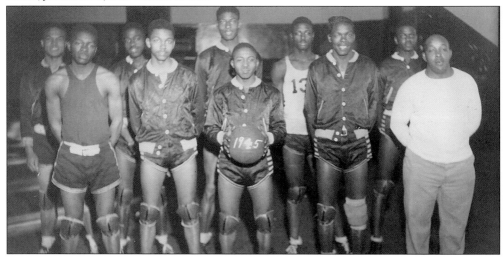

A Year Before the CIAA, 1945. This basketball team poses with Coach Howard "Brutus" Wilson (front row, far right). Before joining the Central Intercollegiate Athletic Association in 1946, the college was a member of the Eastern Intercollegiate Athletic Conference. Members pictured here are Charles Eaton, Charles Branford, Maxter Allen, William Davis, Romie Avery, Theodore Vines (captain), Charles Wellman, Clarence Cooper, and Carl Hargrove.

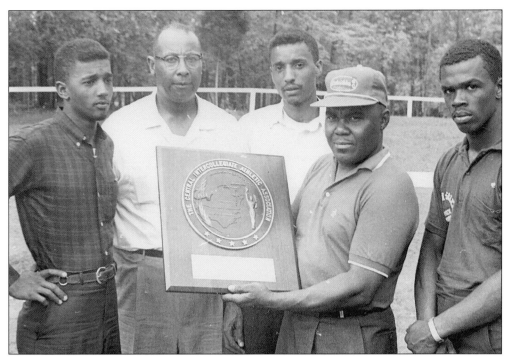

GOLF CHAMPIONS, 1965. The RAMS under Coach Thomas "Tank" Conrad won the Central Intercollegiate Athletic Association Golf Championship. Pictured in this image from left to right are Earl Puryear, Coach Thomas Conrad, Sam Puryear, Winston-Lake Golf Pro, Elvia Jones, and Ostel McKnight.

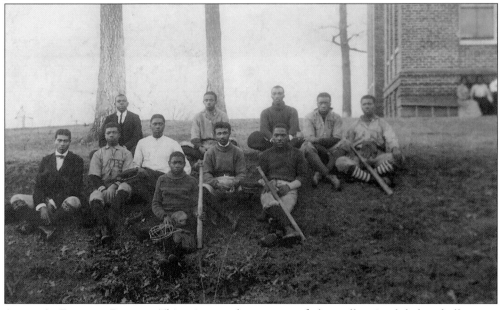

AMERICA'S FAVORITE PASTIME. This picture shows one of the college's club baseball teams comprised of students from the Slater's normal department prior to 1925. These players appear to be older and were probably playing a friendly game amongst themselves or some other team on the campus.

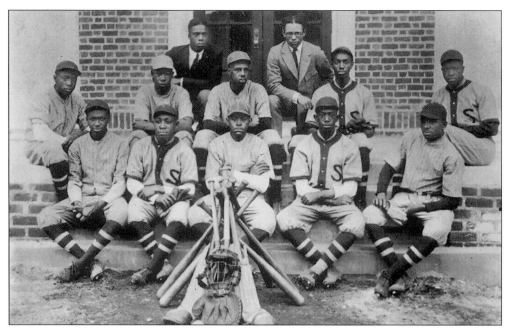

SLATER BASEBALL TEAM, c. 1924. From all written accounts the baseball team had a successful campaign in 1924. The youthful appearance of these players indicates the majority of them are students in the Slater high school department.

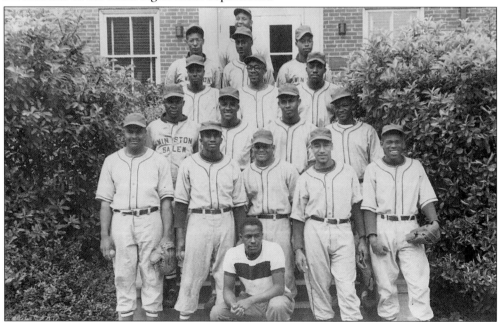

BASEBALL TEAM, 1950. The first baseball "skipper" at T.C. to coach on the collegiate level was Thomas "Tank" Conrad. The team pictured here may have been one of Coach Conrad's inaugural baseball teams. Pictured from left to right are as follows: (front) Potts; (first row) Wallace, Kelly, Wickliffe, Thompson, and Smith; (second row) Murphy, Roach, Woodard, and Reed; (third row) Jones, Bullock, and Williams; (fourth row) Nance, Ervin, and Young; (fifth row) Lawson.

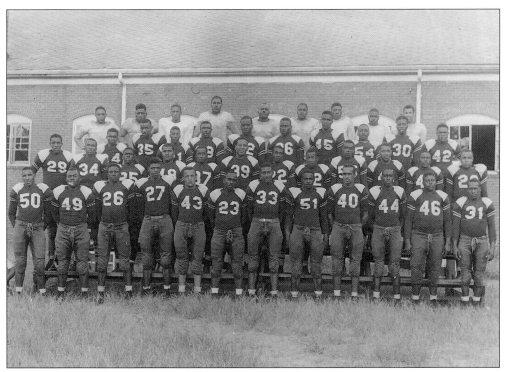

The Best Team Since the Inception of Collegiate Football, 1948. This team was one of the most successful teams to don shoulder pads and a helmet since T.C. began playing collegiate football. Known primarily as a good basketball coach, "Bighouse" Gaines guided this group to an 8-1 season on the gridiron.

Undefeated on the Footbal Field, *c.* **1978.** In 1977 and 1978 the football team under head coach William "Bill" Hayes posted back-to-back undefeated regular seasons. The starting quarterback, Kermit Blount, would later earn another CIAA championship for the Rams in 1999—only this time it would be as the Rams head football coach.

Laurice Jenkins, All-CIAA Performer, 1979. As a senior Jenkins set an all-time scoring record for Lady Ram basketball players. She was the first female basketball player to score 1,000-plus points in her career.

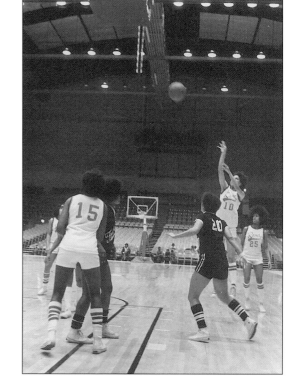

Laurice Jenkins Bombs Away from the Outside, c. 1978. A top scorer, Jenkins helped lead Coach Arthur Chavious's Lady Rams to their first division championship.

BRENDA WINFIELD SHOOTS HER PATENTED JUMP SHOT, 1978. The Lady Rams won this game against CIAA foe Saint Augustines College.

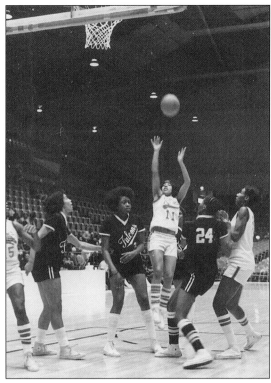

BRENDA WINFIELD, THE OTHER HALF OF THE DYNAMIC DUO. Teaming with fellow player Laurice Jenkins, Winfield helped Coach Al Harvey's Lady Rams repeat as CIAA Southern Division Champions. Winfield's jump shot technique was said to be so "textbook" that men's coach Clarence Gaines often used her in his practices to teach the proper technique to the men.

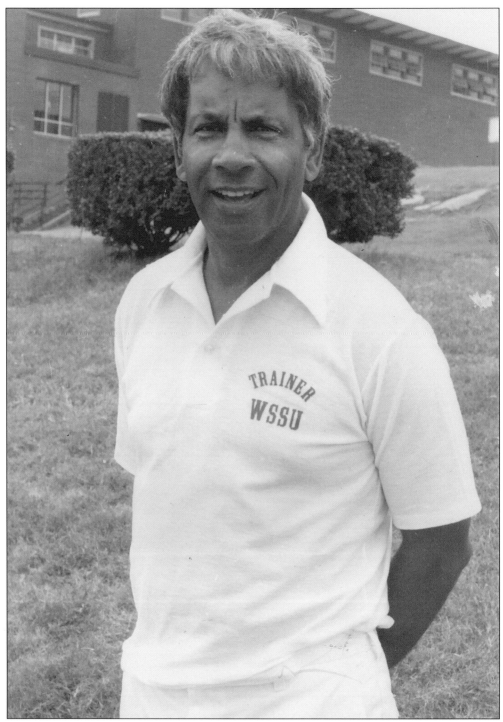

ATHLETIC TRAINER HENRY A. "BUDDY" TAYLOR. He was a trainer for the Rams athletic teams for more than two decades. A well-respected authority on athletic training, he authored *Training and Conditioning of Athletes: Manual for Trainers and Physicians* and served as a trainer for the United States of America Olympic team in 1968 and 1972.

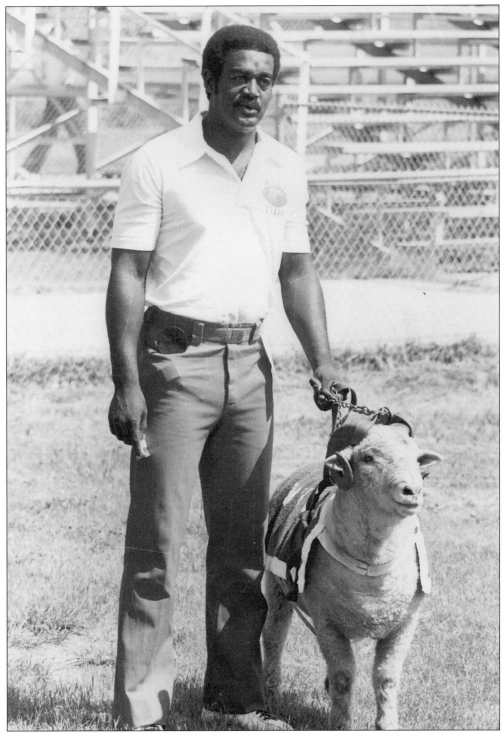

FOOTBALL COACH WILLIAM "BILL" HAYES AND WSSU MASCOT AMON, 1979. A 200-pound, 2-year-old Western/Western Dorsett hybrid ram, Amon belonged to Cleo and Shirley Hyman. Amon made his debut as the university's mascot at the 1978 homecoming football game.

97

TENNIS TEAM, 1949. This may be the college's first intercollegiate tennis team. As early as 1935 the Outdoor Club proposed that students take up tennis as a campus recreational activity.

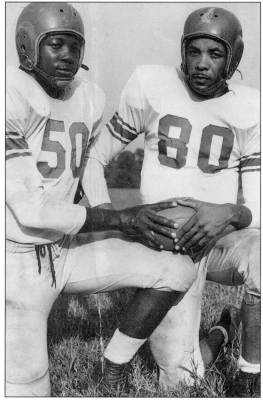

THE GAME IS STARTING TO CHANGE. By 1960, the game of football was going through a transformation on the college and professional levels in terms of equipment and coaching strategies. In this photograph, two Ram football players wear helmets made of a tough, durable material that appears to be leather. The all-CIAA players in this picture are center Victor Johnson (left) and wide receiver James Webster (right). Several years later facemasks would become a standard part of football helmets.

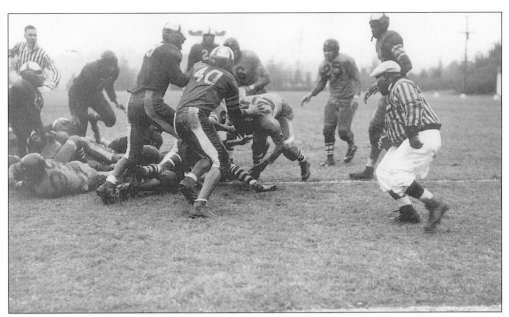

THE T.C. RAMS FIGHT IT OUT WITH THE GOLDEN BULLS OF JOHNSON C. SMITH UNIVERSITY, 1946. This homecoming game took place on the Rams home field at Bowman Gray Stadium. A year earlier in 1945, homecoming activities complete with the annual homecoming football game were inaugurated. Winston-Salem Teachers College (Winston-Salem State University) played Virginia State University to a 6-6 tie.

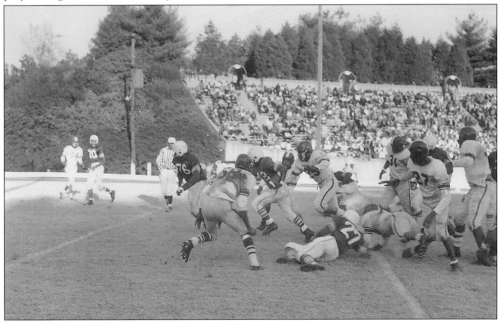

THE "WHY" OF HOMECOMING, 1955. Homecoming was implemented in the 1940s as a means "to build up an Alumni Scholarship and Development Fund, to make it possible for worthy and promising boys and girls to attend Winston-Salem Teachers College, who otherwise would not get an opportunity to go to college." Thomas "Tank" Conrad and his Rams won this game against the Elizabeth City Teachers College Vikings, 31-19.

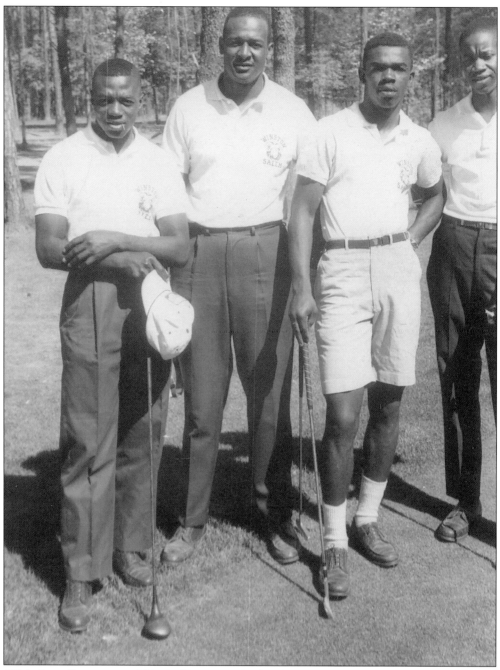

CIAA GOLF CHAMPIONS, 1962. Golf was coached and introduced as an intercollegiate team sport by Coach Thomas "Tank" Conrad. Under his tutelage, the Rams won seven consecutive CIAA golf championships. Pictured from left to right are Nelson Guthrie, Richard Hansberry, Ostel McKnight, and Bernard Bell.

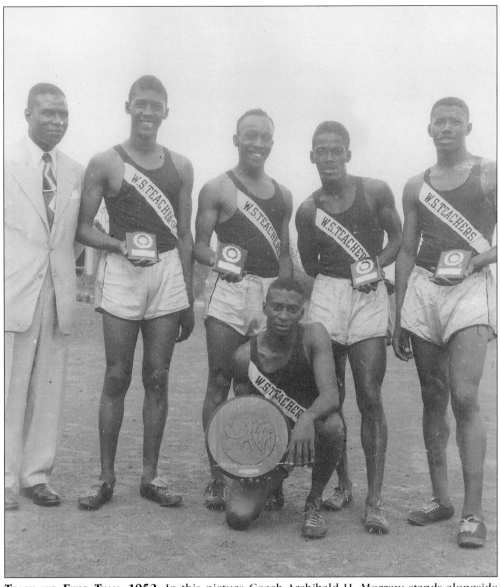

TRACK AND FIELD TEAM, 1952. In this picture Coach Archibald H. Morrow stands alongside the members of the track team. Coach Morrow started the long tradition of bringing New England high school football players and track runners down south to compete for Teachers College.

THE COLLEGE'S ATHLETIC COACHES, 1967. Pictured from left to right are Cleo "Tiny" Wallace, Clarence E. "Bighouse" Gaines, Thomas "Tank" Conrad, and John X. Miller.

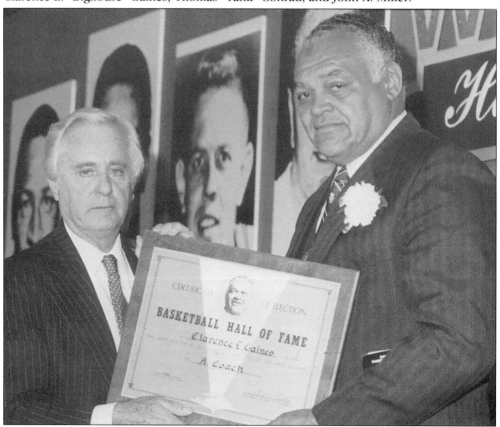

"BIGHOUSE" IS INDUCTED INTO THE NAISMITH BASKETBALL HALL OF FAME, 1983. Noted sportscaster Curt Gowdy and "Bighouse" show off his Naismith Hall of Fame award.

FOOTBALL ALL-AMERICAN, 1962. During this time, as a result of segregation and racial inequalities, some of the best African-American football players could only play at historically black colleges and universities. One such player was Nelson Guthrie. An all CIAA performer, Guthrie set a CIAA rushing record and was named small college all-American.

ALL-AMERICAN WRESTLER COMPETES FOR WINSTON-SALEM STATE UNIVERSITY, 1982. Winston-Salem State University has produced many CIAA wrestling championship teams. Numerous wrestlers from Winston-Salem State University have been selected as all-Americans. Pictured here is the first grappler from Winston-Salem State University to hold this distinction, Horace Williams.

EARL "THE PEARL" MONROE TAKES A SHOT AGAINST N.C. A&T AGGIES, C. 1967. A columnist in Winston-Salem's evening newspaper *The Sentinel*, Luix Overbea, referred to Monroe's scoring as "Earl's Pearls" as a result of his high point production (he led the nation in scoring with a 40-plus points a game average). The name stuck and Vernon Earl Monroe became "Earl the Pearl" for the duration of his professional basketball career with the Baltimore Bullets and the New York Knicks.

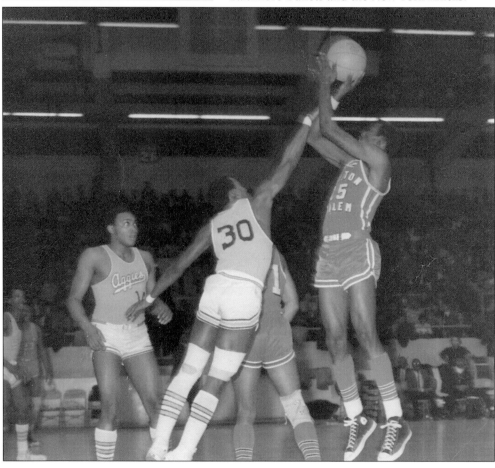

Five

EVENTS AND ORGANIZATIONS

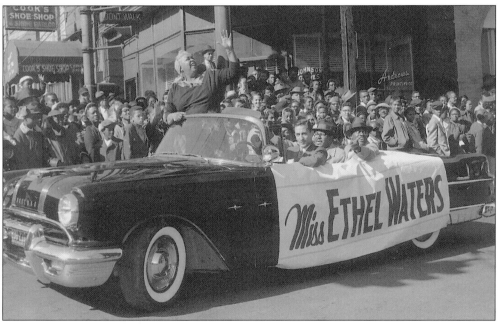

ENTERTAINER ETHEL WATERS IN HOMECOMING PARADE, 1955. Star of radio, television, and film, Ethel Waters performed and crowned Miss Alumni. Pictured from left to right are the following: (back seat) Edwin L. Patterson, Homecoming chairman; Belvedere N. Cook, Alumni president; Joseph O. Lowery, Alumni vice-president; (front seat) Ethel Waters; and Nathaniel Wiseman (chairman of Nominating committee).

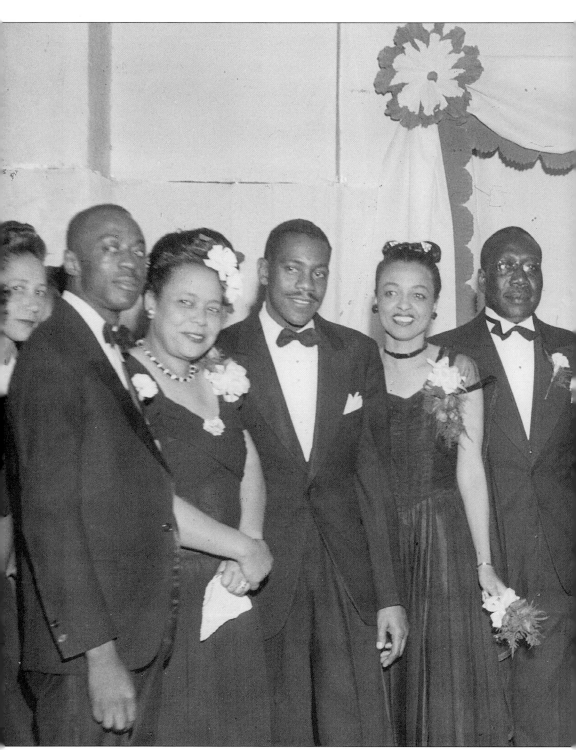

First Miss Alumni Crowned, 1945. Miss Alumni Jennie Green Fletcher is surrounded by her party. Pictured from left to right are J.O. Lowery; Edna D. Fitch, Forsyth County attendant; Johnnie Young; Nannie S. Johnson, runner-up; A.B. Reynolds, president of Alumni

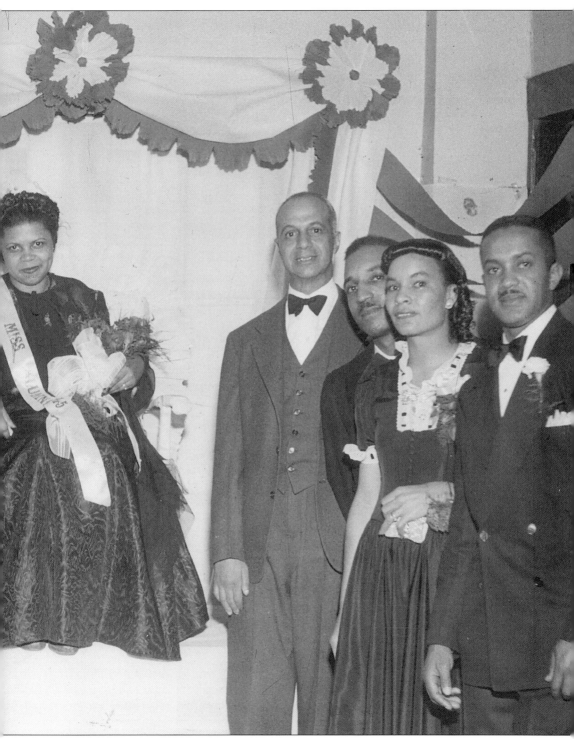

Association; Jennie Green Fletcher, Miss WSTC Alumni; Francis L. Atkins, college president;
F. King Thomas; Viola Covington, Morris, NC Attendant; and John Pat Leadbetter.

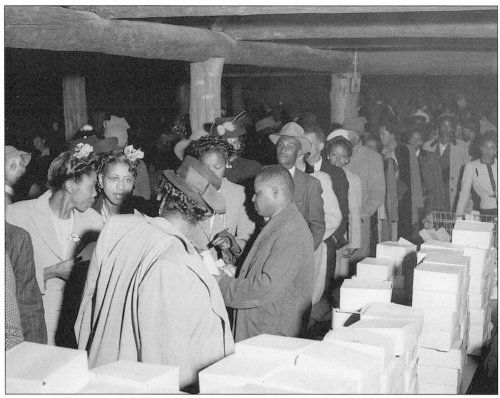

LONG LINES AT HOMECOMING BARBECUE, 1945. The homecoming barbecue was held at the Happy Hill Community Center following the football game from, 5:00 p.m. to 8:00 p.m.

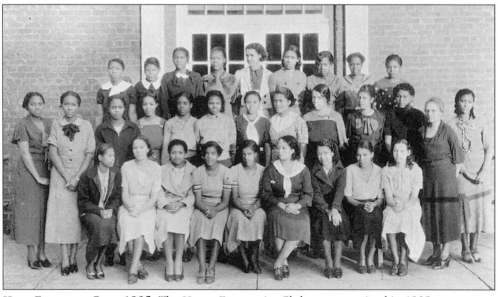

HOME ECONOMICS CLUB, 1935. The Home Economics Club was organized in 1928 to promote social interaction among home economics students, and to acquire and discuss information relevant to home economics.

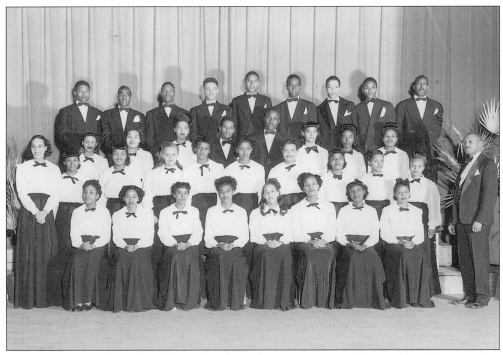

COLLEGE CHOIR, 1948. The college choir has a long reputation of musical excellence, going back to the time of former college President C.G. O'Kelly. The choir has performed at Radio City Music Hall, Lincoln Center, and in La Romaine, France.

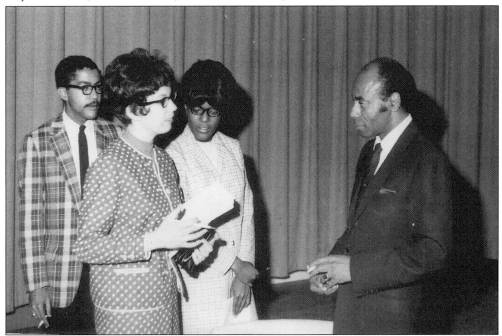

ACTOR ROSCOE LEE BROWNE READS POETRY, 1967. A talented stage actor, Roscoe Lee Browne read the poetry of Rabindranath Tagore, Edna St.Vincent Millay, Dylan Thomas, E.E. Cummings, and Richard Wright to students and faculty gathered in the Fries Auditorium.

109

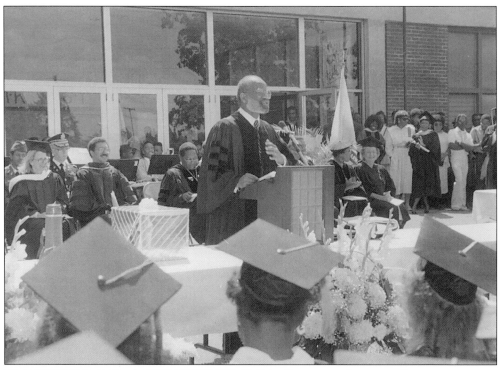

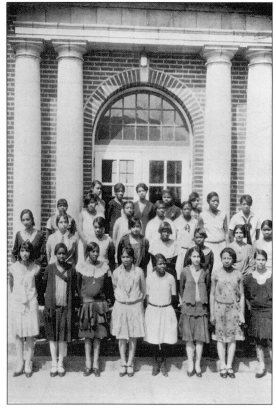

JOURNALIST ADDRESSES CLASS OF 1989. Lerone Bennett Jr., writer, journalist, and editor of *Ebony* magazine, was the commencement speaker in 1989. He was awarded an honorary degree (LL.D.).

UTOPIAN DRAMATIC CLUB, 1935. The first college drama club at T.C. was formed in 1934. The purpose of the organization was to develop dramatic ability and maintain interest in amateur productions. This club was a member of the North Carolina State Dramatic Association for Negro Colleges and Secondary Schools.

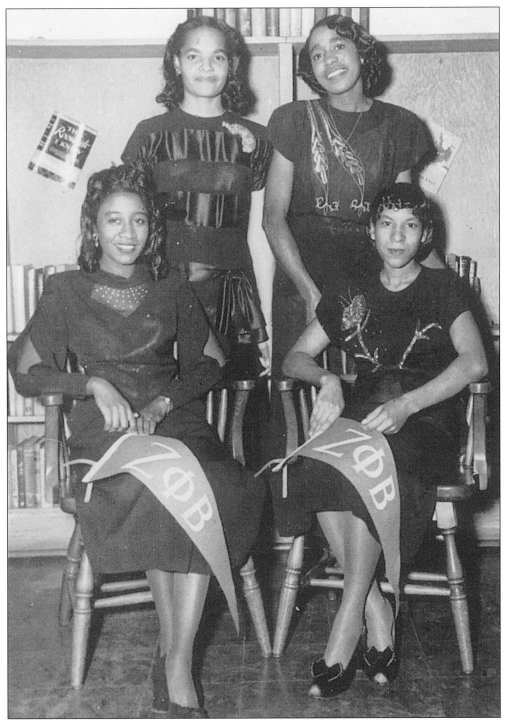

ZETA PHI BETA SORORITY, 1949. Zeta Phi Beta was the first sorority to be organized on the campus of Winston-Salem State University in 1948. Pictured from left to right are the following: (front) Thelma Ellis and Blonnie Washington; (back). Dorothy Long and Kate Jeffries

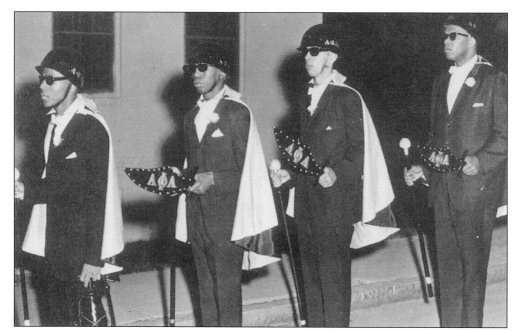

SPHINXMEN GOING THROUGH PLEDGE PROCESS, 1967. The pledges of the Alpha Phi Alpha Fraternity are called Sphinxmen. The Beta Iota chapter, located at Winston-Salem State University, was chartered in 1953.

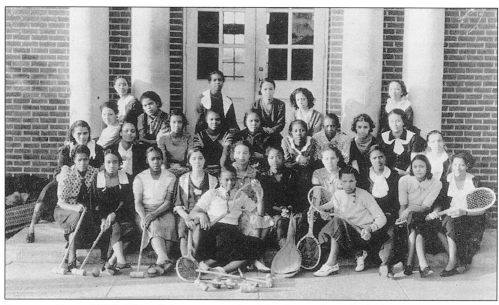

OUTDOOR CLUB, 1935. This club was organized in the spring of 1935. Its purpose was to increase physical fitness, encourage productive use of leisure time, and develop good sportsmanship. Members participated in activities such as tennis, hiking, croquet, baseball, and other outdoor activities.

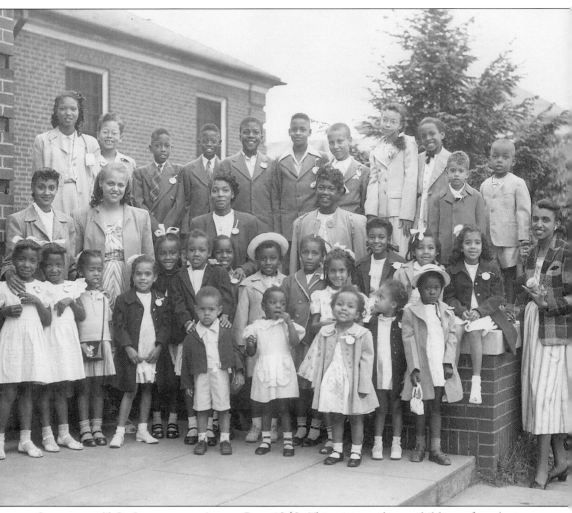

CHILDREN OF T.C. GRADUATES AT ALUMNI DAY, 1949. This picture shows children of graduates with their attendants. The children, ranging in age from 3 to 12 years, were entertained in the lower auditorium of Fries Auditorium.

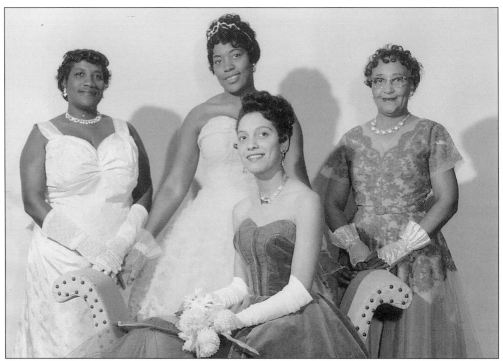

MISS ALUMNI AND HER COURT BEFORE THE BALL, 1958. This Miss Alumni is the daughter of the college's president, Dr. Francis L. Atkins. Pictured from left to right are the following: (standing) Pauline Jackson, third Attendant, candidate of the Rocky Mount, NC chapter; Golden Bassett Wall, first attendant, candidate of the Brown chapter in Winston-Salem, NC; Crissie Martin Tolliver, second attendant, candidate of the Slater chapter in Winston-Salem, NC; (seated) Elinor Atkins Smith, Miss Alumni.

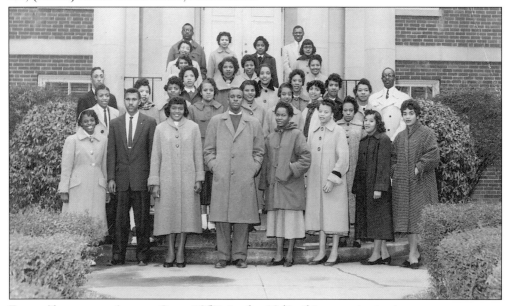

FUTURE TEACHERS OF AMERICA CLUB, 1957. In the 1940s this organization's proper name was the Simon Green Atkins Chapter.

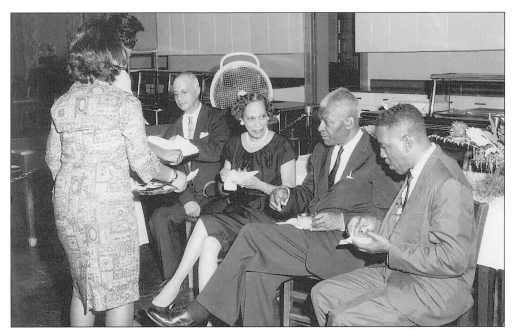

BENJAMIN E. MAYS AT INAUGURATION RECEPTION IN DINING HALL, c. 1961. This image shows Morehouse College president Benjamin E. Mays at a reception in Kennedy Dining Hall with Winston-Salem Teachers College administrators. Pictured from left to right are Francis L. Atkins, former Winston-Salem State University president; Martha Atkins, wife of President Atkins; Benjamin E. Mays; and Kenneth R. Williams, president of Winston-Salem Teachers College.

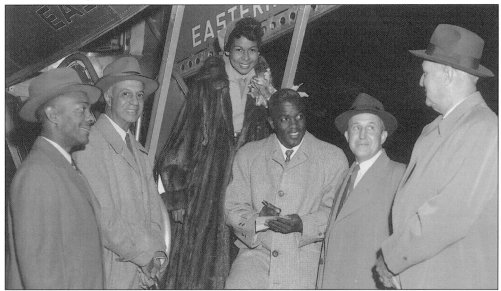

BASEBALL STAR JACKIE ROBINSON COMES TO HOMECOMING, 1954. Jackie and Rachel Robinson were special guests of the college's alumni association. Meeting the Robinsons at the airport are, from left to right, Edward L. Patterson, Homecoming chairman; Dr. Francis L. Atkins, president of the college; Rachel and Jackie Robinson; Marshall C. Kurfees, mayor of Winston-Salem; and Ernie Shore, Forsyth County sheriff.

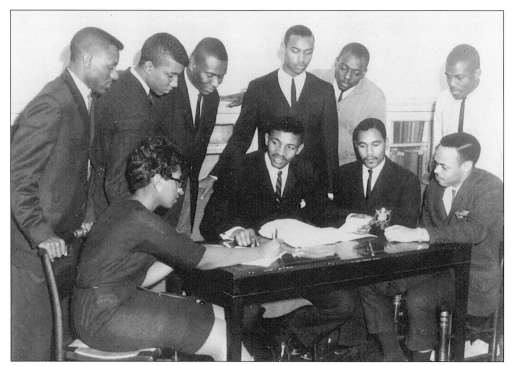

THE STUDENT GOVERNMENT ASSOCIATION DEVELOPS FUTURE LEADERS, 1963. The Student Government Association was founded on the Winston-Salem State University Campus in 1946. One of its stated purposes was "to train for leadership by encouraging attendance at and participation in, the various programs and activities of the college." Pictured from left to right are the following: (seated) Secretary Dollye Kindell, President Larry Womble, Treasurer Roland Penn, and Vice President Haywood Wilson; (standing) Andrew Clinton, George Floyd, Donald Benson, John Tobias, Morty Robinson, and Shane Washington.

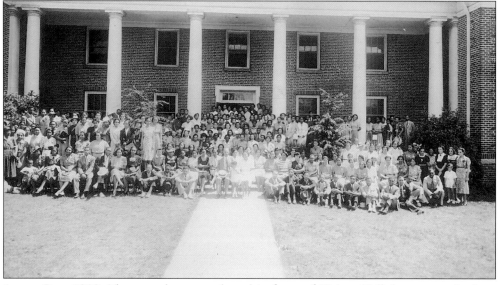

ALUMNI DAY, 1939. These graduates, gathered in front of Bickett Hall, have come back to Winston-Salem to participate in the homecoming festivities.

116

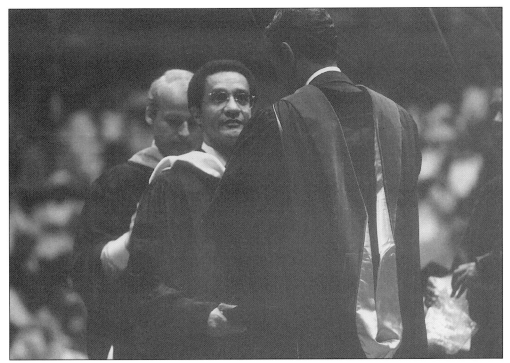

JOURNALIST AND AUTHOR AWARDED HONORARY DEGREE, 1983. Tony Brown was the recipient of a degree from the university after he gave the commencement address to the Winston-Salem State University Class of 1983. Pictured from left to right are John Davis (chairman of the board of trustees), Tony Brown, and H. Douglas Covington (chancellor of the university).

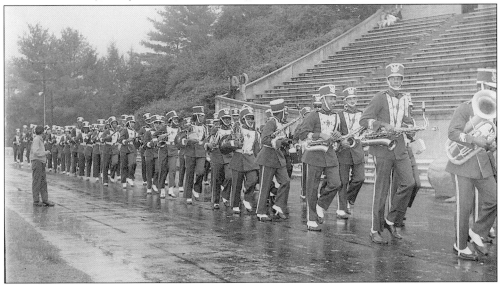

AND THE BAND PLAYED ON. This image is of the marching band, *c.* 1966 or 1967, when the college was Winston-Salem State College. Band members are wearing a traditional spat over their shoes. This style is seen in bands directed by Mr. Harry Pickard. The marching bands of the late 1960s and 1970s, directed by Robert Shepherd and Fred Tanner, tended to wear white buckskin shoes.

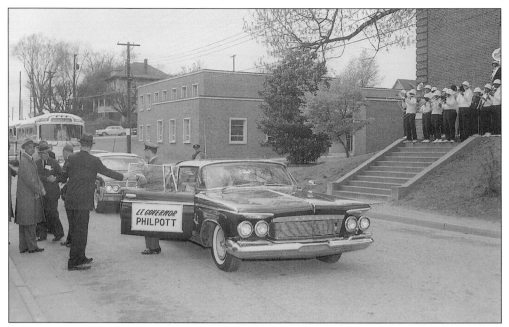

Lieutenant Governor Visits the Campus, c. 1961. Following his election as North Carolina lieutenant governor, Harvey C. Philpott visited the college. In this picture college President Francis L. Atkins (pictured second from left) looks on. The college marching band, pictured on the steps of Eller Hall, plays a musical selection.

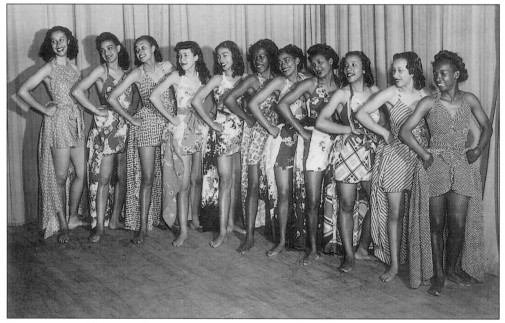

Winston-Salem Teachers College Dance Group, c. 1947. These young ladies are carrying on a long-standing tradition at the college of using dance as a form of artistic expression, creativity, and physical well-being. Pictured from left to right are Ruby Hunt, Elizabeth Grinton, Sarah Ireland, Gloria Diggs, unidentified, Bernice Martin, Johnnie Johnson, Alice Goode, unidentified, Lib Redmon, and Mary Lillie O'Neil.

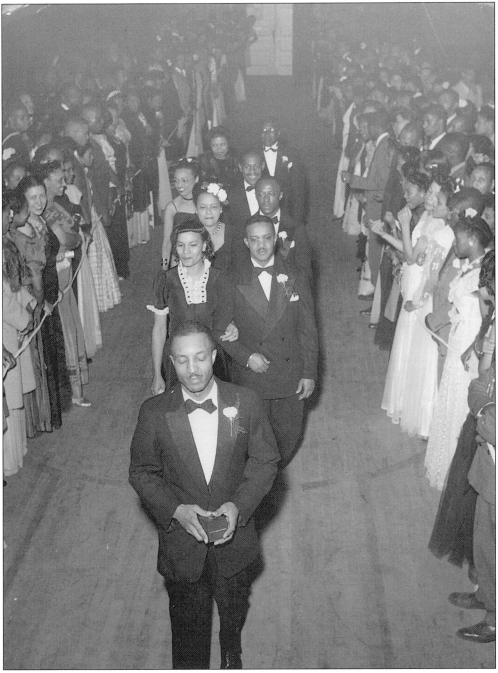

PROCESSIONAL FOR MISS ALUMNI JENNIE GREEN FLETCHER, 1945. F. King Thomas, chairman of Miss Alumni Committee, leads the procession following the crowning of Miss Alumni.

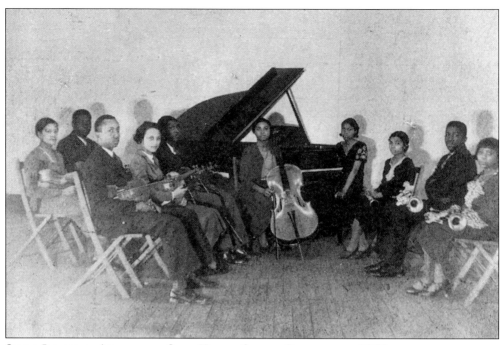

SLATER INDUSTRIAL ACADEMY AND STATE NORMAL SCHOOL ORCHESTRA, *c*. **1933.**

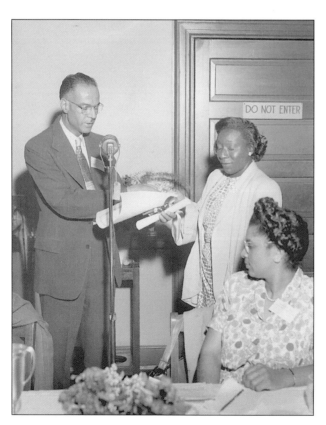

PRESENTATION OF OUTSTANDING ALUMNUS AWARD, 1949. In this picture Bessye Shields Wilder, Class of 1927, is shown receiving the outstanding alumnus award from Jack Atkins, chairman of the alumni award committee. The award was presented at the Alumni Day dinner-business meeting.

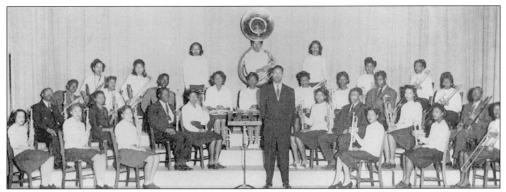

The College's First Band, 1944. The Winston-Salem Teachers College National Alumni Association "Band Project" raised $1,507.25 to purchase 18 instruments. In 1943–44, the band played at chapel services once a week. The college's first band director was music instructor Hamlet Goore.

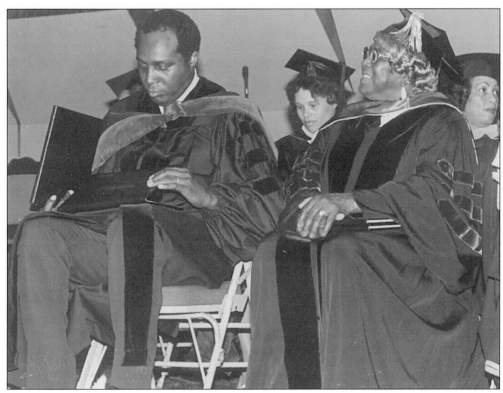

Artist and Civil Rights Advocate Receive Honorary Degrees, 1979. Winston-Salem State University alumnus Selma Burke and National Urban League director Vernon Jordan received the Doctor of Laws the Doctor of Humane Letters, respectively. Jordan was the commencement speaker for the Class of 1979.

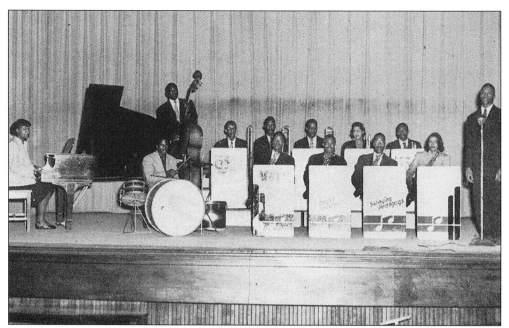

THE SWINGING PEDAGOGS. This musical group was organized in 1945 under the direction of Mr. Hamlet Goore, an instructor in the music department. The Pedagogs brand of music ranged from jazz to big band. Considering the college's primary mission in 1945, the name of the band is quite appropriate—the swinging teachers.

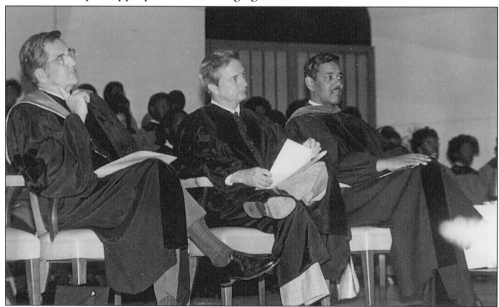

INAUGURATION OF CHANCELLOR H. DOUGLAS COVINGTON, 1978. The formal swearing-in was the climax of a week of activities that included musical concerts, breakfasts, student and staff receptions, and the inaugural ball. Pictured from left to right are William C. Friday, president of the University of North Carolina higher education system; North Carolina governor James B. Hunt; and Winston-Salem State University chancellor H. Douglas Covington.

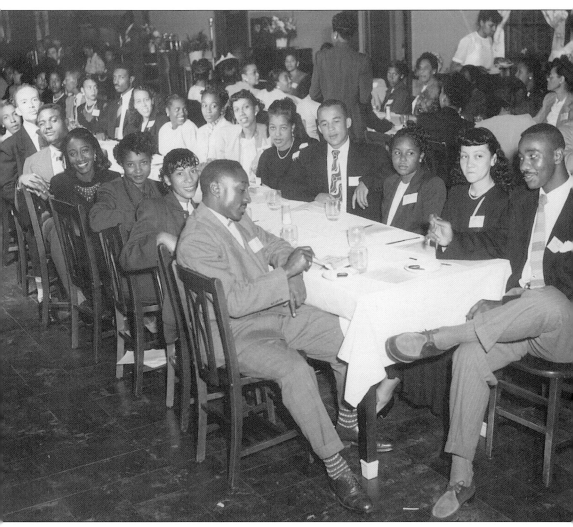

ALUMNI DAY DINNER BUSINESS MEETING, 1949. In this image the Senior Class of 1949 poses for the photographer while patiently waiting for the dinner portion of the meeting to begin. Since these students will be alumni soon they will probably be asked to attend all of the alumni day events.

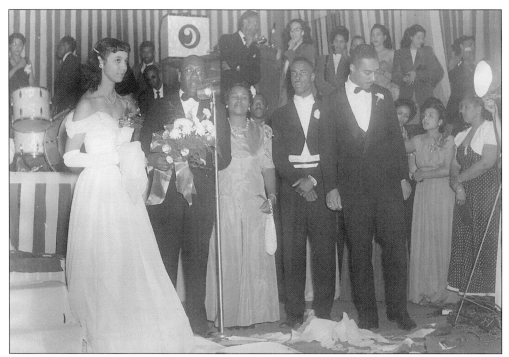

ALUMNI DANCE AND CROWNING OF MISS ALUMNI, 1947. In this picture, alumni association president A.B. Reynolds presents a bouquet of flowers to Miss Alumni of Winston-Salem Teachers College, Clarice Scales. Pictured from left to right are Clarice Scales, A.B. Reynolds (president of alumni association), unidentified, and Henry Jones (college alumnus).

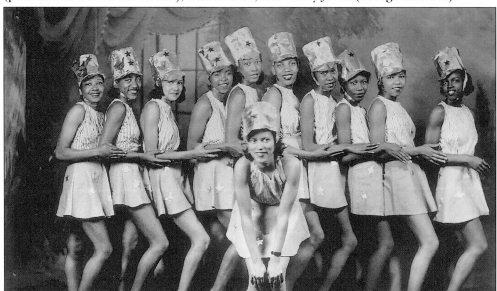

DANCE GROUP AT THE COLLEGE, c. 1939. An organized dance troupe at Winston-Salem Teachers College (Winston-Salem State University) probably started when Remitha Spurlock joined the faculty c. 1935. Pictured from left to right are Grace Reynolds, Stephanie Brown, Hazel Galloway, Olean Black, unidentified, Mabel Johnson, Palmer Curry, unidentified, Ernestine Wilson, Lois Brown, and Remitha Spurlock (center).

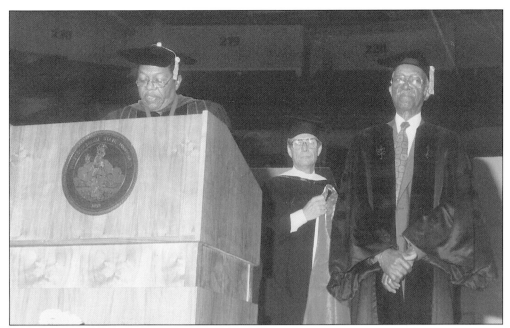

HISTORIAN IS COMMENCEMENT SPEAKER, 1991. John Hope Franklin, the James B. Duke Professor Emeritus, spoke at the Winston-Salem State University commencement program. A prolific writer, Franklin is best known as the author of From Slavery to Freedom. The university conferred upon him the honorary Doctor of Humane Letters degree.

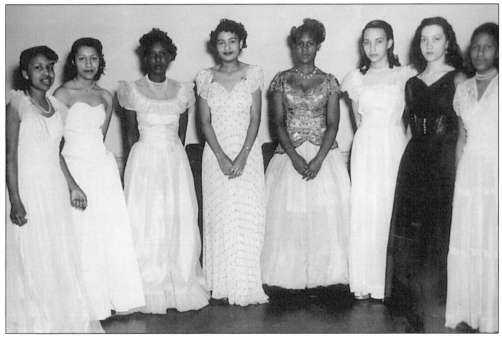

GAMMA PHI CHAPTER OF DELTA SIGMA THETA SORORITY, 1949. This sorority was founded on the campus January 22, 1949. Members of the charter chapter, pictured from left to right, are Vertie Mae Steen, Sarah Drummond, Vivivian Johnson, Willie Mae Leakey, Martha Bethea, Helen Anderson, and Willie Mae Cunningham. Not pictured is Lillian Lawson.

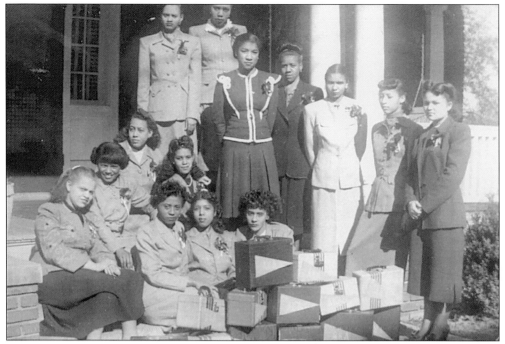

GAMMA LAMBDA CHAPTER OF ALPHA KAPPA ALPHA, 1949. This sorority was organized on the campus January 29, 1949. Pictured from left to right are the following: (seated) Jacqueline Hayes, Gaunzie Caesar, Mamie Allen, Bertha Cobb, Moliere Rhodes, Julia Cobb, and Pearl Clinkscales; (standing) Annie Overby, Katherine Bratton, Margaret Blackmon, Josephine Williamson, Marion Shanklin, Elizabeth Mintz, and Elaine Robinson.

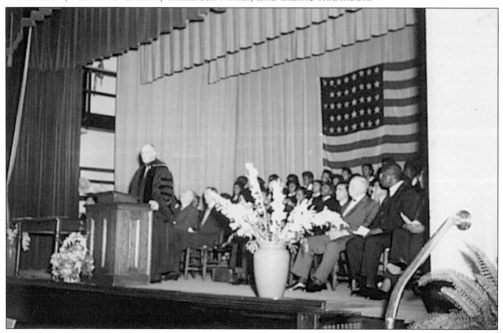

CLERGYMAN SPEAKS AT COMMENCEMENT, 1943. The commencement speaker for the graduating Class of 1943 was Bishop J. Kenneth Pfohl of the Moravian Church's Southern Province.

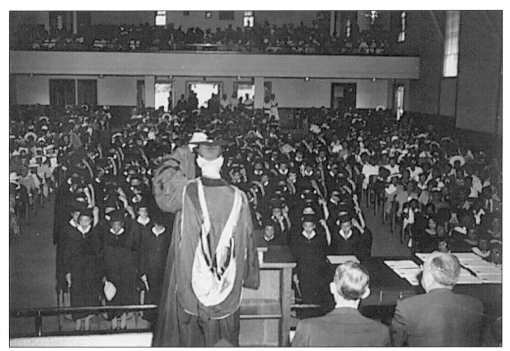

PRESIDENT CONFERRING DEGREES, 1943. President Francis L. Atkins instructs graduates to adjust tassels to the proper side of the graduation cap.

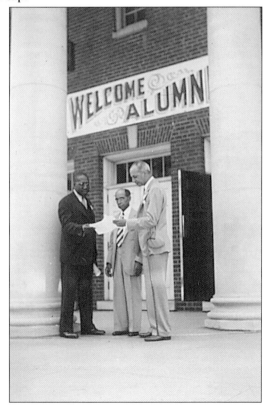

OFFICIALS DISCUSS ALUMNI ACTIVITIES OUTSIDE AUDITORIUM, 1943. Pictured from left to right are A.B. Reynolds, alumni association president; Thomas J. Brown, former alumni association officer; and Francis L. Atkins, president of the college.

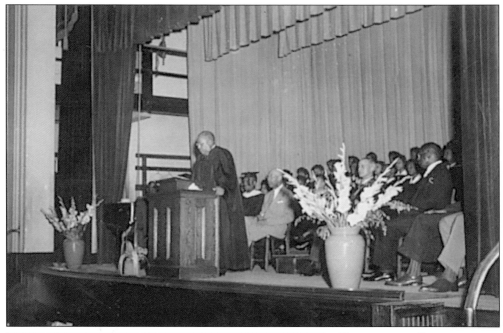

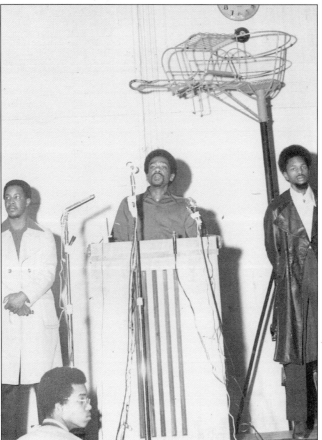

BACCALAUREATE SEVICES FOR THE GRADUATING CLASS, 1943. The baccalaureate service was usually held on a Sunday preceding the actual commencement program. The speaker for the service pictured is Reverend Al James, pastor of First Baptist Church in Roanoke, VA.

BLACK PANTHER SPEAKS TO STUDENTS AND COMMUNITY, 1971. Bobby Seale, co-founder and chairman of the Black Panther Party, spoke to a capacity crowd in Whitaker Gymnasium. In his speech Seale said the Panther Party was not a militant or violent organization. During this time there was a very active Panther party chapter in the city of Winston-Salem.